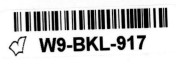 

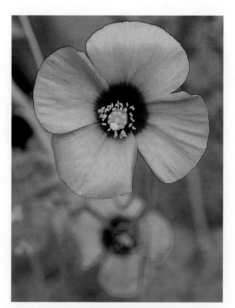

WIND POPPY
*Stylomecon heterophylla*

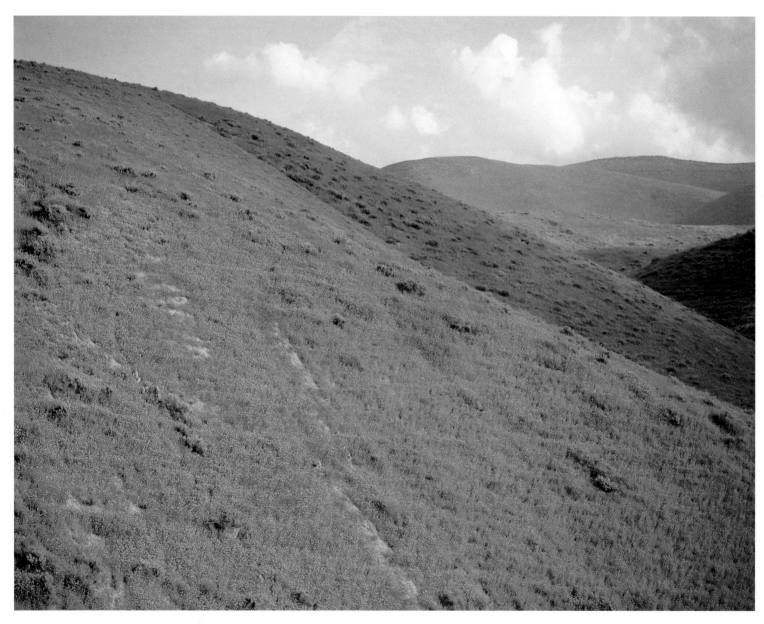

BLAZING STAR  *Mentzelia pectinata*
TANSYLEAF PHACELIA  *Phacelia tanacetifolia*
CALIFORNIA POPPY  *Eschscholzia californica*

Temblor Range ~ Carrizo Plain Natural Area
Bureau of Land Management
Caliente Resource Area ~ Kern County
March 28, 1992

JEFFREY'S SHOOTING STAR  *Dodecatheon jeffreyi*

Frying Pan Lake ~ Marble Mountain Wilderness
Klamath National Forest, Siskiyou County
June 22, 1993

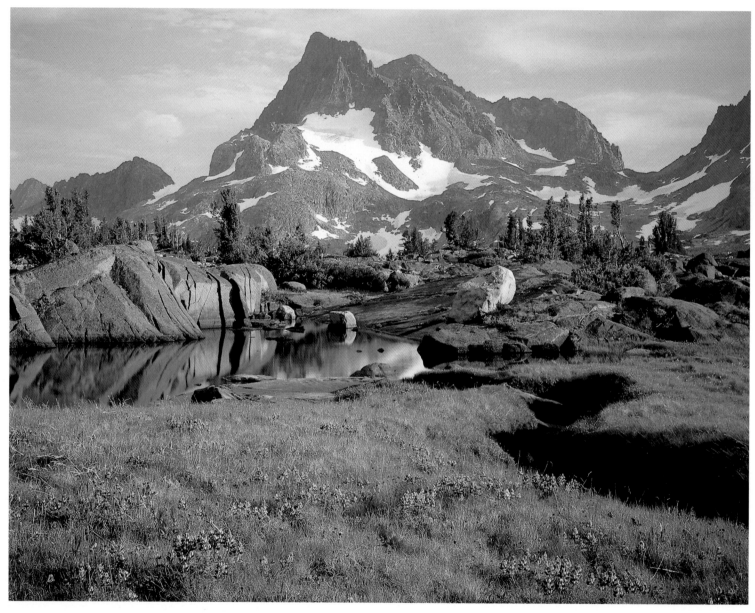

INDIAN PAINTBRUSH *Castilleja parviflora*
DWARF LUPINE *Lupinus lepidus* var. *lobbii*

John Muir Trail on Island Pass ~ Banner Peak & Mt. Ritter
Ansel Adams Wilderness ~ Inyo National Forest ~ Sierra Nevada ~ Madera County
July 10, 1985

Opposite: CALIFORNIA POPPY
*Eschscholzia californica*

Salt Point ~ Salt Point State Park
Sonoma County
April 4, 1994

# *Wildflowers*
## OF CALIFORNIA

*Photography by*
# LARRY ULRICH

*Interpretive Text by Susan Lamb*

COMPANION PRESS
SANTA BARBARA, CALIFORNIA

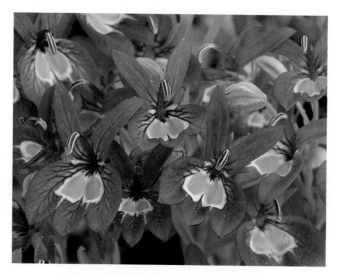

BACH'S DOWNINGIA *Downingia bacigalupii*

Highway 139 near Henski Reservoir
Modoc National Forest ~ Modoc County
June 30, 1993

Companion Press
464 Terrace Road
Santa Barbara, CA  93109
Jane Freeburg, Publisher/Editor
Cover Design by Linda Trujillo

Printed and bound in Korea
through Bolton Associates
San Rafael, California

Library of Congress Catalog Number: 94-71868

ISBN 0-944197-31-0 (paperback)
ISBN 0-944197-33-7 (clothbound)

94  95  96  97  98  ❦  5  4  3  2  1

*For Donna*

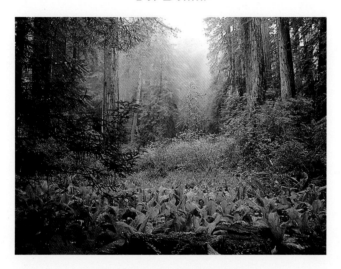

YELLOW SKUNK CABBAGE  *Lysichiton americanum*
SALMONBERRY  *Rubus spectabilis*
COAST REDWOOD  *Sequoia sempervirens*

James Irvine Trail
Prairie Creek Redwoods State Park
Humboldt County
March 11, 1972

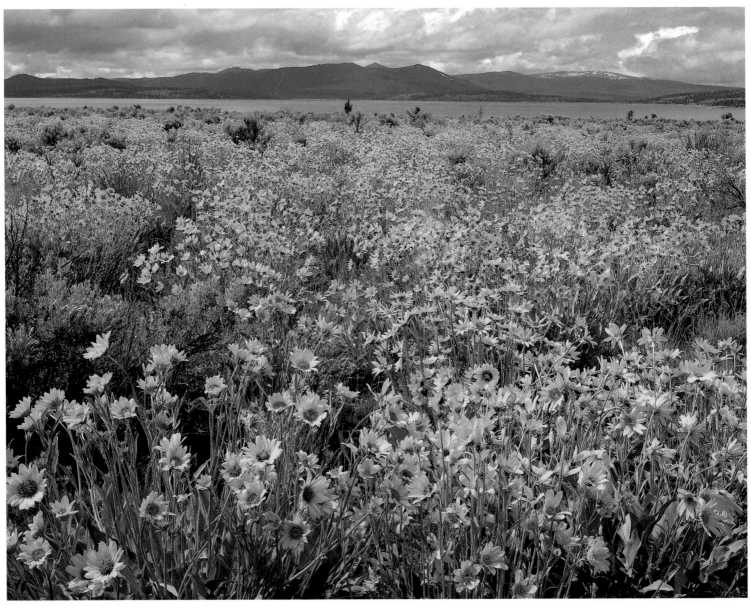

DELTOID BALSAM–ROOT  *Balsamorhiza deltoidea*

Eagle Lake ~ Bureau of Land Management Eagle Lake Resource Area
Modoc Plateau ~ Lassen County
June 5, 1993

Opposite:  CALIFORNIA POPPY
*Eschscholzia californica*

Salt Point ~ Salt Point State Park
Sonoma County
April 4, 1994

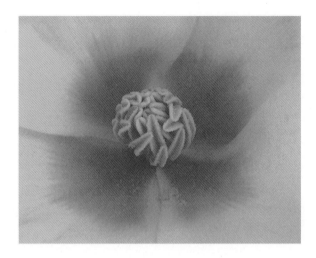

# Preface

*W*ildflowers of California waited patiently for over two decades to be published. The idea of producing an elegant book on California's native flora has been in the back of my mind since I first picked up a camera. Although this portfolio includes images that span my entire career, the bulk of the work was shot during the spring seasons of 1992 to 1994, when California's seven-year drought was moderated by abundant rainfall. All across California I heard reports of "best bloom in decades," "haven't seen this species in years" and "the hillsides are covered." Enough to make a photographer crazy, running around a state as big as California. My dream book has come true.

This book is not a field guide; many fine guidebooks are already available for field identification. My goal is to give a visual interpretation of the diversity, abundance, and beauty of California's native wildflowers. But I encourage readers to take this publication into the field to enhance their own knowledge and appreciation. The plants represented here are not necessarily the most common or showy. This is a collection of photogenic and cooperative species—they (or I!) were in the right place at the right time. Each photograph is accompanied by a date and location so that interested readers may have an idea of where and when they might find different flowers blooming. But keep in mind that many factors, including weather, affect blooming seasons from year to year.

Flowers seem to bloom at the windiest times of the year. I spent many hours laying on the ground, looking through the viewfinder, waiting for that brief moment when the light is right and the wind seemed to quit—hopefully at the same time. Many of these images represent hours of frustration; several days of hard work condensed to just half a second of success.

Identifying scientific names of the species I photograph is very important to me. Keying out to the Latin names—and finding a consensus on common names—became almost as great a challenge as the photography. I am a professional photographer, but an amateur botanist! I learned very quickly that flowering plants are complex and botany is not an exact science. Armed with a hand lens and the newest edition of *The Jepson Manual: Higher Plants of California*, I spent countless hours attempting to make this book as accurate as possible. I am satisfied that, in most cases, my classifications are correct. I enlisted the help of Lisa Acree, Steve DeBenedetti, David Graber, Tony LaBanca, Malcolm McLeod, Bryan Ness, Teresa Sholars, Nancy Warner, and Barbara Williams. I would like to thank these expert botanists, who bravely offered their opinion based solely on review of photographs. I am also grateful to Phyllis Faber of the California Native Plant Society, who reviewed the text.

For twenty-two years my wife Donna has been my constant companion, lover, and friend. Her quick eye and inherent creativity have helped me beyond words. Without our common vision many of these images would have been left in the field, untaken. Donna has assuredly not been along just for the ride. I dedicate this book to her.

California's size and diversity make it a challenge to photograph. But that diversity is disappearing at an alarming rate due to loss of habitat and competition by introduced species not native to California. The fifth edition of the California Native Plant Society's *Inventory of the Rare and Endangered Vascular Plants of California* lists 852 species, subspecies, and varieties as rare, threatened, or endangered. As our state's population grows, more habitat falls to development, creating an even greater challenge to all of us with wildflowers in our hearts. The remaining wild spots, from large parcels to tiny tracts, are vanishing. Wildflowers can survive wildfires and drought—but not the bulldozer.

It is my desire that this collection of images increases visual appreciation of our flora and becomes a temptation for personal discovery. I also hope it expands awareness of the fragile future of California's native flora and inspires a commitment to safeguard that future.

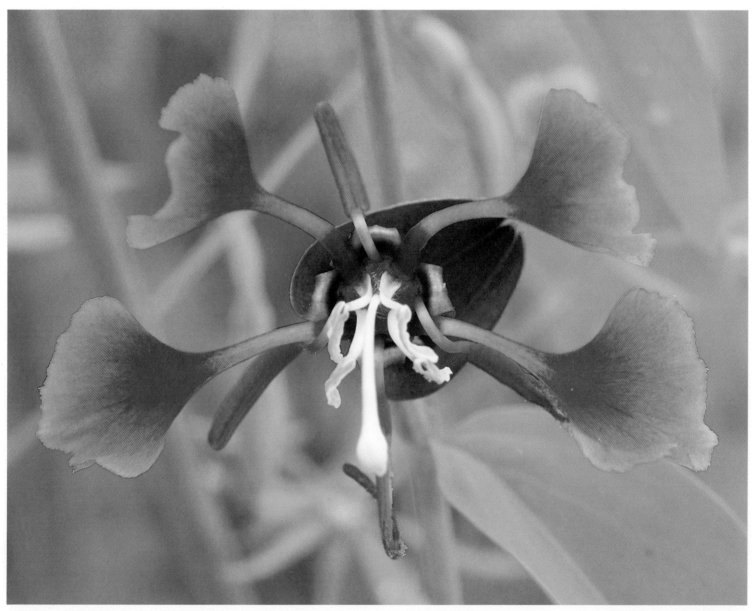

ELEGANT CLARKIA
*Clarkia unguiculata*

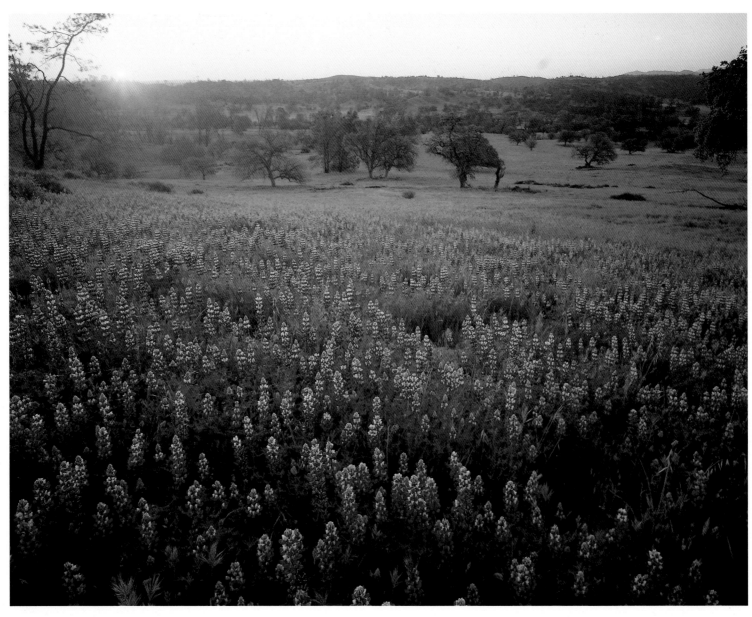

DOUGLAS' LUPINE *Lupinus nanus*
Shell Creek Valley, South Coast Ranges
San Luis Obispo County
March 24, 1988

Opposite: PADRES' SHOOTING STAR
*Dodecatheon clevelandii* ssp. *insulare*
Christy Ranch ~ Nature Conservancy's Santa Cruz Island Preserve
Channel Islands ~ Santa Barbara County
March 19, 1994

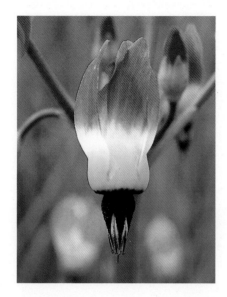

# *What is a flower?*

*"Nobody sees a flower, really. It is so small it takes time—we haven't time—and to see takes time, like to have a friend takes time."*
—GEORGIA O'KEEFFE

Flowers are living allegories: metaphors of hope, love, joy, and transformation. Blooming briefly yet brilliantly—unfolding and shining, fading and falling apart—their appearance every year reminds us that life is really a glorious cycle of returning seasons, not a dogged march from then to there. Flowers are Nature's most eloquent voice, speaking to us of optimism and fertility. Flowers remind us that we share the Earth with other living things. Nature can almost be disregarded—treated as a faceless background—until flowers bloom. Then we are awestruck at the delicate beauty of life in its myriad forms, its exuberant colors, and its subtle fragrances. And although we may not realize it, it is the fragrances that affect us the most. We humans interpret scent with the part of our brain close to the home of emotion—the limbic system. Fragrances stir in us memories without words: sensations of past springtimes and summers, strong feelings of both happiness and grief.

Flowering plants are at the very center of our existence, necessary to our survival whether we appreciate them or not. They ultimately nourish not only us but nearly all the creatures of the land and air by making sunlight into fruit, foliage, roots, and seeds to eat. They even help us breathe, by splitting water molecules in their leaves to free oxygen and absorbing carbon dioxide, thereby purifying our atmosphere.

Flowering plants are more akin to humans than they might seem. The chlorophyll molecule of plants and the hemoglobin molecule of our blood are similar in structure, except that the atom at the center of the chlorophyll molecule is magnesium instead of iron. A form of hemoglobin itself is present in the nitrogen-fixing nodules on lupine roots. Phytochrome, a pigment that gauges how many hours the sun is shining in order to trigger flowering and other plant developments, is also similar in structure to the pigments in our bodies that enable us to use vitamins to develop *our* tissues, bones, and blood.

Humans have long used flowers as remedies for everything from pain (arnica) to palpitations (monkshood), influenza (sage) to acne (roses). We have used them as incense (brittlebush), seasoning (wild ginger), aphrodisiacs (violets), and hallucinogens (morning glories). But as the great conservationist Aldo Leopold put it: "The last word in ignorance is a man who says of an animal or a plant, 'What good is it?'" It is well worth remembering that the exquisite form and fragrance of a flower is designed not for *us*, but to attract the insects, birds, and bats that may carry its pollen to the next blossom of its kind.

Many flowers contain both male and female parts within the same blossom, and some are capable of pollinating themselves. Some plants have separate male and female flowers on the same plant, as does coast manroot with its many large male and a few diminutive female flowers on the same vines. Violets cover their bets by producing showy blooms for pollinators first, then following up with inconspicuous, self-pollinating flowers. In most circumstances, it is better for flowering plants to cross-pollinate—to exchange their genes with another plant—which keeps a species fit and able to adapt to environmental changes.

Wild flowers are entirely practical forms of life. About eighty percent of them are designed to appeal to insects, and many take advantage of the wind. We humans transform our environments to suit ourselves, but the diversity in flowers reminds us that plant life has always been resourceful enough to adapt to the environment. Flowering plants are like us, yes, but they make the most of the world the way it really is—windy and full of bugs.

One April weekend, I took a watercolor class at Point Reyes. Our teacher wisely urged us: "When painting wildflowers, always take the *pollinator's* point of view." He understood that everything about a flower—its shape, color, scent, even its time of blooming—is determined by its pollinators. In getting to know

California's wildflowers, it is useful to know something about how their crawling, hopping, and flying partners perceive them.

Imagine the world of an insect! Think of a hairy, black-and-yellow bumblebee glinting with golden pollen, wallowing in the stamens of a magenta beavertail cactus flower. Consider how delicately butterflies perch on shooting stars, unfurling their long, tubelike tongues to probe for nectar. Watch flies basking in the sunlight-focusing dishes of clubmoss ivesia, or ghostly-pale moths fluttering about the desert at dusk to find freshly-opened dune evening primrose.

Flowers first appeared on Earth about one hundred thirty million years ago, during the time of the dinosaurs. Scientists believe that the first flowers produced a tremendous amount of pollen, to be carried by the wind to fertilize their neighbors. But producing so much pollen consumed a great deal of a plant's resources. Insects are a more efficient and dependable agent of pollination than the wind, so many flowering plants gradually evolved colors and scents to attract insects to transport their pollen directly to other flowers, instead. They produced less pollen, but it became more sticky. The earliest flowers probably looked much like the archetypal broad-petaled flowers drawn by children. Beetles were common then, as now, and flowers of that shape, like prickly poppies, are very accessible to beetles.

Over time, both flowers and their pollinators have evolved together into new and wonderful forms. Naturalist Charles Darwin wrote about this in the 1860s: "We thus see that the structure of the flowers of Orchids and that of the insects which habitually visit them, are correlated in an interesting manner." Throughout history, numbers and kinds of insects have increased. But some of them were clearly not suitable for certain flowers—not big or strong enough to reach the next blossom of a species that grew far apart in the desert, for example. Many flowers evolved ways to attract certain insects or birds, which would then visit other flowers of their kind. Specific flower shapes attract the "right" pollinators, ensuring that less pollen will be wasted.

For many insects, plant pollen is an important food, rich in proteins. California poppies produce lots of easy-to-reach pollen, attracting beetles with a spicy scent. The beetles get it all over themselves as they eat it. This is why poppies grow so close together—so that clumsy, pollen-dusted beetles do not have far to fly in order to pollinate another one.

COAST
MAN-ROOT
*Marah oreganus*
COMMON
HORSETAIL
*Equisetum arvense*

Coastal Trail
Redwood National Park
Del Norte County
May 17, 1985

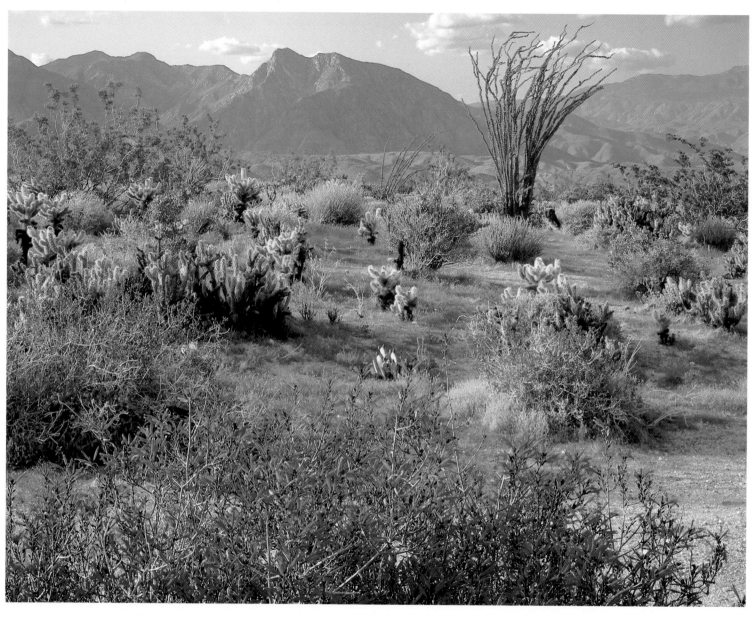

CHUPAROSA *Justicia californica*
OCOTILLO *Fouquieria splendens* ssp. *splendens*
TEDDY-BEAR CACTUS *Opuntia bigelovii*

Indianhead from Yaqui Meadows near Glorieta Canyon,
Anza-Borrego Desert State Park ~ Sonoran Desert
San Diego County
March 10, 1992

16

Pollinators also visit flowers to sip nectar, the sugary fluid with the Greek name meaning "drink of the gods." It is produced in nectaries at the bottom of special petals, which sometimes form hair-lined tubes to limit sippers to those with long beaks or tongues. Chuparosa, the spectacular nectar-rich, red-flowered shrub that blooms early in southeastern California deserts, is named for the hummingbirds that visit it as they migrate up from Mexico in February and March. Hummingbirds are called *chuparosas* in Spanish, which means "rose-slurpers." But nectar takes considerable resources to produce, and so some kinds of flowering plants rely on other ways to attract pollinators.

Fragrance itself can be the lure. Certain butterflies visit flower after flower, particularly those of the family *Polemoniaceae* such as showy phlox, mustang clover, and whisker brush, to collect a bouquet of fragrances in which to drench female butterflies during courtship. *Andreni rozeni*, a little desert bee that collects pollen only from the brown-eyed evening primrose, also mates among its fragrant blooms, and nests in the sands around it.

Warmth attracts insect pollinators, too. Because they cannot generate their own heat as warm-blooded mammals can, insects must find ways to heat their tiny wing muscles so that they can fly. Many light-colored, bowl-shaped mountain flowers such as balsam root and Sierra layia turn their heads to follow the sun, focusing its energy into their centers where all sorts of beetles, bees, and other flying insects bask in temperatures twenty or more degrees higher than their surroundings. Some flowers, like fleabane, even close at night which further protects pollinators, who become covered by more pollen the longer they stay. Skunk cabbage attracts flies by its fetid odor, mimicking the rotting material on which flies lay their eggs. But the plant's *spadix*, the thick central spike that bears its miniature flowers, also generates as much as fifty degrees of warmth. On cold evenings, flies snuggle up next to it only to find themselves temporarily trapped within the *spathe*, the huge yellow leaf that encloses the spadix. As the spadix matures, its pollen-laden guests clamber free of the now-withered spathe.

Some flowers attract lots of different insects in lots of different ways, so a whole gamut of activities—feeding, mating, egg-laying, basking, preying on others, and dying—takes place on them. Predatory flies lying in wait on cow parsnip, a fragrant, shallow bloom of many little flowers clustered together, eat

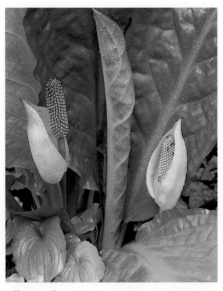

YELLOW SKUNK
CABBAGE
*Lysichiton americanum*

Skunk Cabbage
Creek Trail
Redwood National Park
Humboldt County
March 9, 1991

or lay their eggs upon other insects seeking pollen and nectar. There are also predatory plants; the California pitcher plant, for example, attracts insects then traps and digests those caught by downward-pointing hairs lining its nectaries.

Botanists group flowers into families that are based upon similarities in their structure, and put very closely-related flowers together into *genera* and finally into species. Since flowers have evolved in response to pollinators, we can understand why members of a certain flower family or genus look the way they do. We can begin to recognize our fellow forms of life, delight in their intriguing adaptations, and even greet them as my elderly friend Sylvia used to do: "Why, *hello* little *mimulus* . . . I know your cousin in Sausalito! The bees are crazy about her, too."

One of the most common flower families is the *Asteraceae*, also known as the *Compositae* or Sunflower Family. Blossoms of this family, such as *Monolopia*, are made up of lots of ray flowers (the long ones that we usually think of as petals) surrounding dozens of tiny disk flowers clustered in a yellow or brown, velvety button in the middle. To avoid self-pollination, the disk flowers mature from the outside in: first their male parts, then their female. Bees sipping nectar from the disk flowers also move from the outside in, ending up with pollen from the flowers closest to the middle caught on their feet and fur. When the bees land on the next sunflower, they again start around the edge of the disk, fertilizing that one's female flowers with the previous one's pollen.

Bees are important pollinators of flowers today. Because honeybees seek nectar for their hives—far more than they need as individuals—they are persistent and wide-ranging. Native bumblebees are so big that they need a lot of fuel and so they, in particular, visit lots of flowers. Bumblebees are also bulky, clumsy fliers that tend to fly upwind for greater control. As a result, beach evening primrose flowers open downwind, so that bumblebees may more easily enter them. Many non-social bees—common in the deserts of California—cover a wide range as well.

PRICKLY POPPY
*Argemone munita*

Monitor Pass Road
Toiyabe National Forest
Sierra Nevada
Mono County
June 10, 1993

18

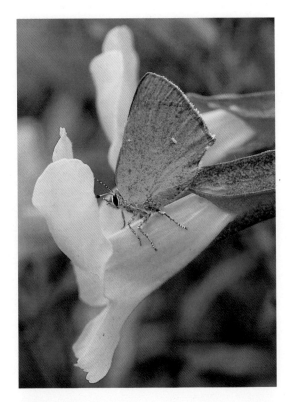

BUSH MONKEYFLOWER
*Mimulus aurantiacus*
COASTAL GREEN
HAIRSTREAK
BUTTERFLY
*Callophrys viridis*

Montana de Oro State Park
San Luis Obispo County
March 16, 1994

Powerful enough to push into flowers that other insects cannot open, bees are large enough to weight down the wing petals of a sky lupine and expose the passage to nectar and pollen inside its *keel*. Bees are so fuzzy that a lot of pollen sticks to them. Their tongues are longer than those of many other insects, and because they have such long tongues, some flowers cater to bees by forming deep nectaries lined with stiff bristles, discouraging smaller insects. But bees can be bandits, too. They bite into the extremely long, hummingbird-adapted spurs of columbines to get at any nectar their tongues cannot reach.

Bees are most attracted to the color blue; they do not see red or orange at all. They also see colors that humans do not, ultraviolet for instance, and so a flower may be marked with garish designs that are invisible to us but appeal to bees. Bee flowers often have nectar or honey guides; lines or dots that lead bees to their nectar (and past its pollen). They advertise this nectar with a sweet fragrance that bees "hear" through their velvety antennae.

Flies, including midges and male mosquitoes (which consume only nectar during their lives) have short tongues, and most commonly visit shallow blossoms such as salmonberry and goldfields. They are particularly attracted to yellow or white flowers.

Among the most delightful pollinators—they have been called "flowers escaped from their stems"—are butterflies and moths. Both have long tongues that unfurl to form sucking tubes. Although they do not seem to prefer any color visible to us, butterflies do require a place to perch while sipping nectar. They are often seen on wide, sweetly-scented flowers. Orange-and-black monarch butterflies are drawn to milkweed, which lures them as well as lots of other kinds of insects with its fragrance and abundant nectar. Milkweed pollen develops on little strands, which catch on insects' claws. Only strong insects like butterflies and bees can pull their feet, festooned with pollen sacs, free of milkweed flowers. Weaker creatures remain snagged and die struggling on the plant.

Moths hover as they feed, and so they do not need broad or firm petals to serve as platforms. Because they are active at night, moths can most easily locate large, pale, strongly-scented flowers, many of which bloom only from dusk until morning. One genus of moth, the *Tegeticula*, has a lock-and-key relationship with the flowers of yuccas such as Joshua trees. The moths lay their eggs in yucca flowers as they pollinate them, and some of the resulting seeds nourish the moths' larvae in return.

Hummingbirds are attracted to red, as anyone who gardens wearing a red hat can testify. They require a great deal of nectar to fuel their rapid wingbeats, and stay very busy visiting tubular red flowers such as California catchfly (named for the stickiness that keeps crawling insects from reaching their blooms), Tracy's larkspur, and Applegate's paintbrush. But other birds visit flowers, too, including the finches and orioles fluttering about ocotillos in early spring. However, most birds have a poor sense of smell, and so flowers don't need to have a scent to attract them.

Many flowers change color after pollination, to indicate they have already been pollinated. By various means—including adding or losing pigments or changing the acidity of their sap—flowers modify the color of their central eyes, throats, nectar guides, or petals. Birds, butterflies, bees, and flies all learn to interpret when nectar and pollen are available and confine their efforts to these flowers. The white spot on the *banner* or upper petal of a sky lupine, for instance, becomes purple after pollination, a signal that the flower has no more nectar to offer.

The fragrance of flowers changes over time as well. Studies show that honeybees prefer fresh sunflowers pungent with volatile chemicals indicating lots of pollen and nectar, to musty flowers at the end of their blooming cycle. Plants may also wilt their own petals with ethylene gas. Bitterroot flowers fade quickly after pollination, crumpling to avoid attention and to devote the plant's resources to producing seeds.

Flowering plants have a myriad of adaptations to perpetuate their kind. They also cope with the many variations in California's climate and geology by means of some rather remarkable strategies.

BEACH EVENING
PRIMROSE
*Camissonia cheiranthifolia*
ssp. *cheiranthifolia*

Christy Beach
Nature Conservancy's
Santa Cruz Island Preserve
Channel Islands
Santa Barbara County
March 20, 1994

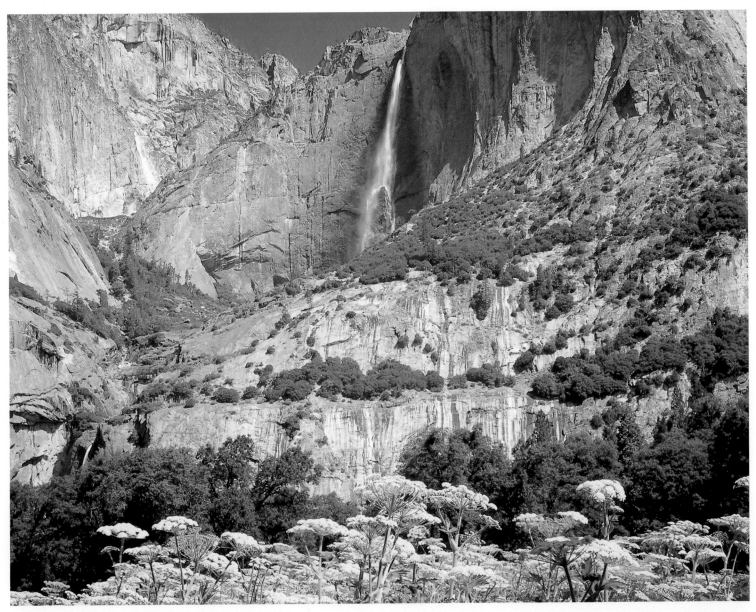

COW PARSNIP *Heracleum lanatum*

Yosemite Falls ~ Yosemite National Park
Sierra Nevada ~ Mariposa County
June 26, 1985

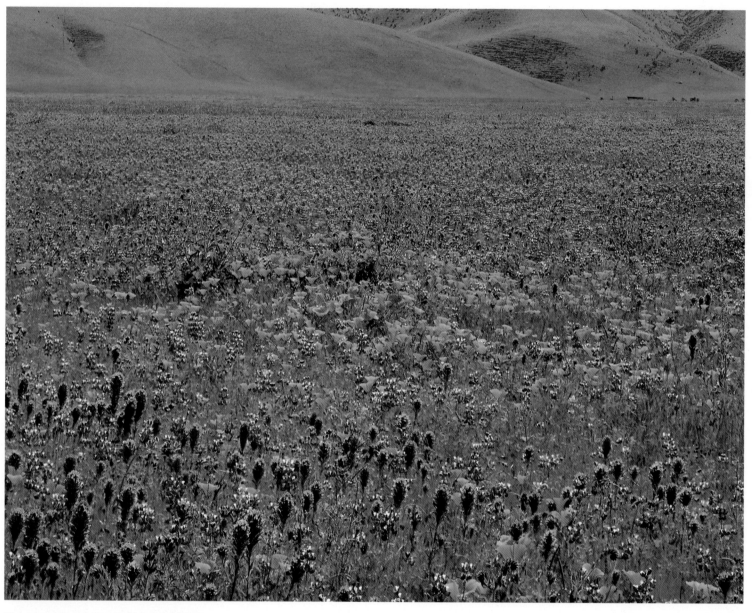

CALIFORNIA POPPY *Eschscholzia californica*
PURPLE OWL'S-CLOVER *Castilleja exserta* ssp. *exserta*
DOUGLAS' LUPINE *Lupinus nanus*

San Joaquin Valley near Grapevine ~ Kern County
March 24, 1988

Opposite: CANYON PEA
*Lathyrus vestitus* var. *vestitus*

Ortega Highway ~ San Juan Creek Canyon ~ Santa Ana Mountains
Cleveland National Forest ~ Riverside County
March 23, 1994

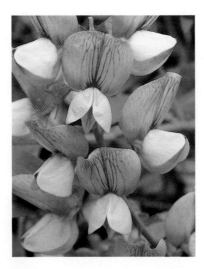

# California's Wildflowers

*E*very spring when I was a child, my father would take me to see the rhododendrons blooming in San Francisco's Golden Gate Park. He'd plunge his face—wide-eyed behind his hornrims—right into a clump of blossoms, inhale and then pull away, his eyebrows sparkling with pollen and a beatific grin showing his crooked teeth. Then he would urge me to do the same: to surround myself with the full glory of those translucent pink, velvety blooms. How the splendor of those flowers comes back to me now!

There were many other places we went in California, just to experience flowers. My favorite spots were east of the central coast ranges, in the grassy, undulating hills dotted with ancient oak trees. Luxuriant with purple lupines and brilliant orange poppies, those hills shimmered in delicately-scented summer air that was literally vibrating with bees. All childish fears and frustrations vanished quickly in that paradise. California is the ideal place for such flower quests.

Botanists know of more than five thousand seven hundred species of flowering plants in California, members of more than one hundred fifty families. About twenty percent of these are *endemic,* or native just to California. The state sustains such a rich flora because of its mosaic of habitats, from desert to seashore, interior valley to mountain. *The Jepson Manual: Higher Plants of California*, is the bible of California plant lovers. Jepson divides these four basic habitats into dozens of "phytogeographic subregions," where specific plant communities have developed in response to differences in latitude, precipitation, elevation, and soil.

## LATITUDE

Since blooming takes a great deal of energy (which plants derive from sunlight), most plants wait to flower until the length of the day "tells" them that 1) there will be enough hours of light to sustain them, and 2) their pollinators will be on the scene. Because the longer, warmer days of spring arrive much sooner in the southern part of the state, members of common families such as *Asteraceae* (seaside daisies), *Liliaceae* (mission bells), and *Fabaceae* (canyon peas) pop out in early March on the southern coast, while it may be another six weeks before their cousins—common madia, California fawn lily, and redbud—begin to bloom in the north. The length of day that cues plants to bloom also signals birds to migrate and insects to emerge. Just as the desert sunflower bursts into bloom, the solitary bees that specialize in its pollen emerge from burrows where they lie dormant the rest of the year.

Overall, California has a Mediterranean climate of wet winters and dry summers, but it rains much less in the southern part of the state. The dryness of southern California means that plants decompose very slowly, if at all. After blooming, their leaves and flowers dry into a sort of thatch that shades the ground, and nutrients bound up in their tissues are not restored to the soil. Some flowering plants take advantage of the fires that inevitably follow years of drought, flowering abundantly in sunny soil made suddenly fertile by the ashes of burned brush. Although it is difficult for those of us who live in fire-adapted habitats to appreciate them, these wildfires awaken some species of native plants. After catastrophic southern California fires in coastal scrub and chaparral, flowers rarely seen for decades bloom again, including red maids, canyon pea, and wild Canterbury bells.

## PRECIPITATION

Rainfall also lessens with increased distance from the sea, particularly east of the low coastal ranges that intercept moisture. The Pacific high, a fickle zone of high pressure, can also block rain from some areas of the state for years in a row. "Fog-drip" along the coast, however, can be significant, offering several inches of moisture to flowers such as Douglas iris.

In many parts of California, shallow depressions fill with rain or snow from Pacific storms in winter, but dry up in early spring. The daunting conditions of

DOUGLAS' IRIS
*Iris douglasiana*

Salt Point
Salt Point State Park
Sonoma County
April 4, 1994

these "vernal pools" defeat most plants, but Bach's and two-horned downingia bloom cheerily around their edges for a short time after evaporation has exposed them to pollinators. The downingia are able to flower and set seed quickly, by drawing on reserves of moisture they absorbed while overwintering in the nutrient-rich muck as little rosettes of leaves.

## ELEVATION

Plants at high elevations usually wait longer to flower, until they are likely to attract pollinators and avoid freezing. At ten thousand feet in the rocky White Mountains of southern California, Nuttall's linanthus delays blooming until June, while at six thousand feet in the nearby San Gabriel Mountains its fellow family member prickly phlox blooms as early as March.

Although the colder temperatures of high elevations push flowers to bloom later and set seed in a shorter time, California's mountain ranges have an advantage over the surrounding lowlands in that they receive more moisture. Banks of deep snow dribble meltwater down high mountain slopes for weeks or even months, while summer thunderstorms shower them with rain.

BACH'S DOWNINGIA
*Downingia bacigalupii*
NEEDLE NAVARRETIA
*Navarretia intertexta* ssp.
*propinqua*

In dry vernal pool near
Gold Digger Pass
Modoc National Forest
Modoc Plateau
Siskiyou County
July 1, 1993

## SOILS

California has long been geologically active, producing granites and serpentines that make generally infertile soils. The Sierra Nevada is composed mainly of sterile granite, while outcrops of serpentine pepper the Coast Ranges. Weathered from igneous and metamorphic rocks, serpentine soils have high amounts of heavy metals toxic to flowering plants. Where these soils occur, even an area that is moist and sunny may have surprisingly few flowers, except in pockets where humus has accumulated. Some plants are specially adapted to poor soils, however, to survive on rocky hillsides. Indian warrior and purple owl's-clover are *hemiparasitic*: they tap the roots of other plants for water and nutrients.

Many plants do best in humus soils, which are rich in decomposed organic matter. These soils hold moisture well and provide important nutrients. They tend to occur in low-lying areas such as the Sacramento Valley, where a variety of lilies thrives despite the long, dry summer.

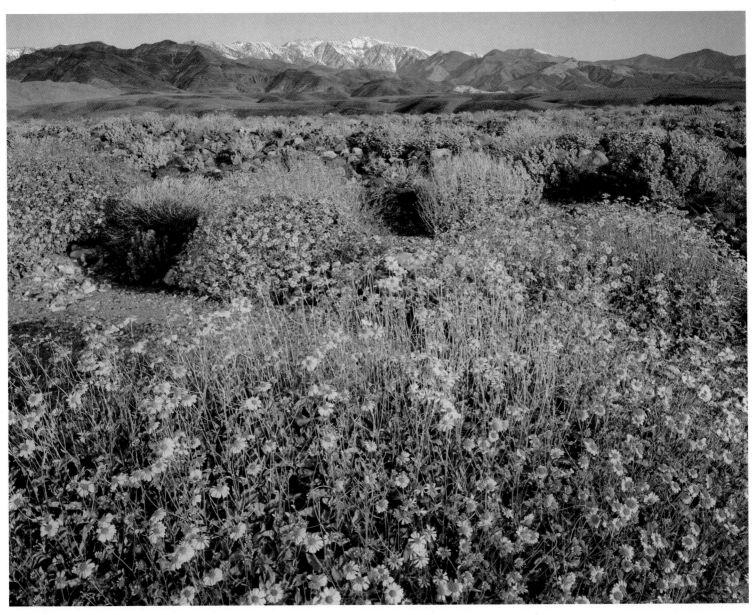

BRITTLEBUSH
*Encelia farinosa*

Galena Canyon and Telescope Peak
Death Valley National Park
Mojave Desert ~ Inyo County
March 19, 1993

### A Tour of Wildflower Habitats

As the months go by from February through July, the geographical diversity found in California makes it possible to see bloom after bloom of wild flowers throughout the state. Beginning in the desert in late February or early March, desert sunflowers and brittlebush shine like sunlit gold. A few weeks later, colorful Munz' tidytips, Chinese lantern phacelia, and devil's lettuce carpet the Carrizo Plain. California poppies, purple owl's clover, and bird's eyes soon come up at the southern end of the Central Valley, blooming a few hundred feet higher or a hundred miles further north with each passing week. May brings flowers to the higher elevations—whitestem swertia on the Modoc Plateau; Harlequin lupine and Humboldt lilies in the Sierra Nevada. As the summer warms, heathers nod in the cooler highlands and lilies blossom along shady streams. But by July, there are really only two places in California with flower displays—in the higher elevations of the Sierra Nevada and Klamath ranges, and on the northern beaches.

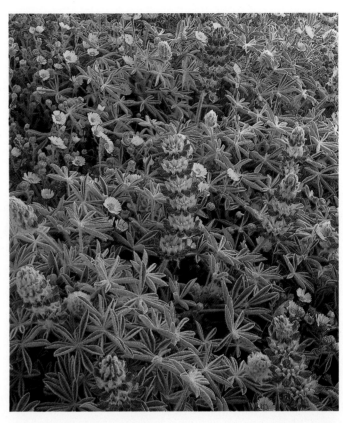

CHICK LUPINE
*Lupinus microcarpus*
var. *densiflorus*
COMMON MADIA
*Madia elegans*
ssp. *vernalis*

Near Shell Beach
Sonoma Coast
State Beach
Sonoma County
April 20, 1988

Plants need sunlight, water, and nutrients. Depending upon where they grow in the state, plants will receive more or less of these basic necessities of life. Whichever is in the *shortest* supply in a given area is considered the "limiting factor," and will have the most influence on what grows there. In the desert, for instance, the limiting factor is water. In years of adequate rainfall, a dozen Mojave desert stars may blossom along with many stiffly-bristled leaves on a single plant. In dry years, the entire plant may be limited to a single naked bloom.

The pictures and photographer's notes in this book will show you when and where to look for flowers. It is also very helpful to know about local variations in sunlight, temperature, moisture, and dirt, because one of the most delightful things about California is that it is a land of surprises.

# DESERTS

California's deserts are among the lowest, hottest, driest places on the planet. Rainfall only totals about eight inches in a good year, and much of it comes in the winter when temperatures are too cold and days too short for plants to make use of it. As a result, the most common characteristic of desert annuals is their reduced size. Parish's goldpoppies, for instance, are very like California poppies, but much smaller by comparison due to lack of water in their desert habitat.

There are three deserts in California: the scorched Sonoran, bordering Mexico (this region is also referred to as the Colorado Desert); the higher, somewhat moister Mojave where Joshua trees grow; and the much cooler Great Basin Desert to the north on the border with Oregon. In all of these deserts, dessicating winds blow mercilessly much of the year. Soils are generally poor, because there is no moisture to create humus and loose dirt is easily carried off by the wind. Late-summer thunderstorms may douse the Mojave and the Sonoran deserts, but little of the rain from summer storms in the Great Basin reaches the ground before evaporating.

Because conditions are so harsh in the Sonoran and Mojave deserts, flowers called *ephemerals* carry on their entire life cycles in just a few weeks there. Purplemat is a classic ephemeral: a mat-forming plant that spreads rapidly over the ground and bears dozens of little bell-like flowers in years of adequate rainfall, with only a few straggling stems and flowers in dry years. Its desert cousin common phacelia is likewise fast-growing, but finds shade and support by entwining itself in the lower branches of other shrubs. In order to conserve moisture and energy, Death Valley mohavea successfully mimics the appearance of sand blazing stars—in which bees find nectar and lots of pollen to eat—to attract bees, even though the mohavea itself produces only a little pollen and no nectar.

Although annuals are common in wet years, a surprising number of perennials survive in the desert throughout the year by means of various strategies. The sticky stems of desert sand verbena become caked with sand, which holds them down in the wind and armors them against the sun and dryness. Desert lilies overwinter as bulbs storing enough water to produce substantial foliage and flowers in the early spring. Desert agaves, impressive members of the lily family, withstand extremes of dryness and temperature by growing slowly for decades as

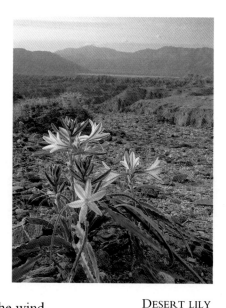

DESERT LILY
*Hesperocallis undulata*

Fonts Point and the
Santa Rosa Mountains
Anza-Borrego
Desert State Park
Sonoran Desert
San Diego County
March 21, 1992

a knot of tough, fibrous leaves, then very suddenly thrusting up one huge stalk loaded with flowers only to die right after setting seed. Cactus—succulent, spiny plants endemic to the western hemisphere—bloom just briefly when conditions permit.

In the Great Basin desert, it is dry but not nearly so hot as in the southern half of California. Old man's whiskers turn upward after being pollinated, so that the seed plumes they soon develop can be caught and dispersed by the wind. Field owl's clover and Applegate's paintbrush manage with less nourishment or moisture by being partially parasitic on the roots of other plants.

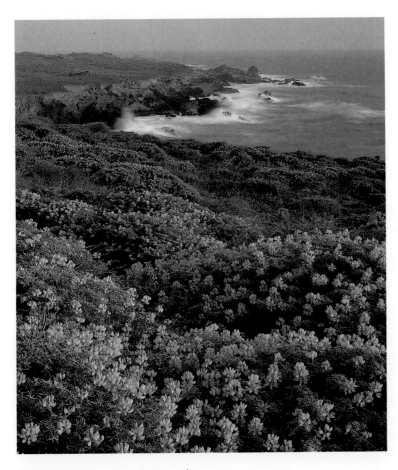

YELLOW BUSH LUPINE *Lupinus arboreus*

Stump Beach Cove ~ Salt Point State Park ~ Sonoma County
June 21, 1985

## COAST

By contrast to the desert, the seacoast is relatively damp and mild all year. Nevertheless, California is a thousand miles long, stretching from hot and arid Mexico to cool, moist Oregon. With an average annual rainfall of only fifteen inches, Los Angeles is a near-desert of fragrant coastal sage scrub and bush monkeyflower. Eureka, however, receives more than three times as much precipitation, enough to sustain a temperate rainforest of redwoods and California rosebay.

The clammy mist that blows over the northern coastline much of the summer brings moisture, but because it is so salty it can nonetheless dessicate the plants growing there. As a result, plants of the northern shore are often succulent like beach morning glory, or develop huge underground tubers like the coast man-root. Flowers that are more protected in shady canyons

and forests, such as western trillium and redwood sorrel, are among the first to bloom in the state's far northern regions.

Much of the coastline is rugged and spectacular, with low mountain ranges interspersed with small valleys. North-facing slopes are cooler and more moist; east-facing slopes are drier but more sheltered from the winds. Scattered on these grassy slopes are Johnny jump-ups, lupines, and paintbrush. Purple nightshade and pitcher sage bloom in partial shade. In soggy places among shooting stars and crimson columbines, red dots on the faces of common yellow monkey-flowers guide bees to nectar. To protect their reproductive parts from rough weather, the ubiquitous California poppies furl their petals when it turns cloudy.

The coast is often rocky, but pockets of soil trapped among the rocks are enriched by the decay of past generations of plants. Yellow bush lupine, seaside daisies, Douglas' iris, and cow parsnips grow in these niches. Madia, and several other yellow *Asteraceae* also called tarweeds because of their aromatic, resinous foliage, are common along the coast. On the islands west of Santa Barbara, unique species of flowers such as the Santa Cruz Island bird's foot trefoil have evolved after long isolation from their mainland cousins.

SEASIDE DAISY
*Erigeron glaucus*

Portuguese Beach
Sonoma Coast
State Beach
Sonoma County
April 5, 1994

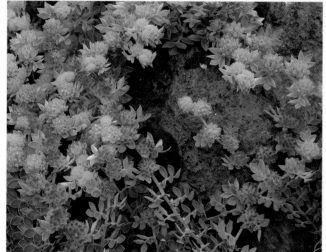

SANTA CRUZ ISLAND BIRD'S-FOOT TREFOIL
*Lotus argophyllus* var. *niveus* ~ ENDANGERED

Platts Harbor
Nature Conservancy's Santa Cruz Island Preserve
Channel Islands ~ Santa Barbara County
March 27, 1990

## INTERIOR VALLEYS

California's extensive interior valleys bask in sunshine most of the year. Until this century, a network of rivers and streams carried soil to the valleys from the highlands, and kept it moist. Wetlands sustained vast riparian forests and billions of pollinating insects. With the aid of an elaborate drainage system, farmers now grow crops in these valleys, replacing a once-diverse native flora.

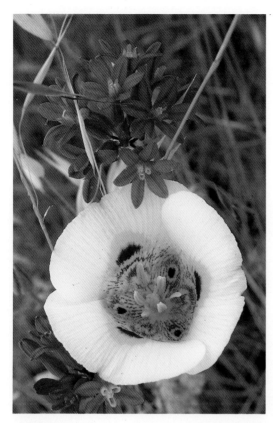

SUPERB
MARIPOSA LILY
*Calochortus superbus*
ROUNDTOOTH
OOKOW
*Dichelostemma congestum*

Masten Road
Sacramento Valley
Tehama County
May 8, 1993

The interior's dry heat often draws a blanket of cool, moisture-laden air from the coast over the intervening hills. As a result, flowers are more abundant on the western side of the Central Valley, and scarcer on the Sierran side.

Lilies are well-adapted to the interior valleys. Ookow, mariposa lilies, and gold nuggets store nourishment from the previous growing season and moisture from the wet winter months in their bulbs, enabling them to bloom profusely in May. Gold nuggets, one of California's most common lilies, readily reproduce by means of little bulblets that root to become new plants, thereby lessening their dependence upon pollinators that may be scarce in years of drought.

Because of the grasses that grow quite high by early summer, flowers of the interior valleys must bloom early or be very showy. Several species of *Collinsia* bloom on foothills in the southern half of California from March through May, before the grasses grow so high that these enchanting Chinese houses are hidden from view. Bright red California catchfly later poke up well above the mature grasses in order to attract attention.

## HIGHLANDS AND MOUNTAINS

Conditions in California's mountains and high plateaus are challenging: cold, windy, rocky, shaded by forests or else battered by the elements above tree line. Yet there are many flowers in the high country too, the treasured gifts of a brief spring and summer.

Most alpine flowers—dwarf lupine and rock fringe among them—are small and hug the ground to stay out of the wind. White heather grows under very difficult conditions: soggy crevices at eight to ten thousand feet above sea level. Its sweet little bell-shaped white flowers reflect intense solar radiation at that elevation, while protecting visiting insects from the wind.

One of the most unusual flowers in mountain forests is the snow plant, which has no green foliage at all. Even before the snow has completely melted, its bright-red flowers emerge in shady places on the forest floor where it obtains

its nutrients from decaying plants. Most other flowers that grow well in mountain forests need a little sun. Mountain dogwood blossoms, conspicuous with their halos of creamy-white bracts, gleam in the filtered sunlight below Douglas firs, western hemlocks, and other evergreen trees.

Indian rhubarb produces sprays of delicate pink flowers on mountain riverbanks, where its thick roots reach plenty of water. Bog orchids also "need to keep their feet wet," as do seep spring arnica and common yellow monkeyflower.

Not surprisingly, the showiest high-elevation flowers bloom in meadows where soil has accumulated, water is available from ponds or streams, and surrounding mountains provide some shelter from the wind. Common camas cast a violet hue over emerald green meadows dotted with deep-pink shooting stars. Tall white bistort, blue dwarf lupine, raspberry-colored Lemmon's paintbrush, and the aptly-named, bright pink elephant's head can fill bowl-like mountain meadows with colors so intense they bring hikers close to tears. Such intense emotions are among the greatest gifts we receive from flowers. In these moments of intimacy with Nature, we transcend the artificial and connect with the *real*, real world.

So study the exquisite photographs in this book. Think about why the flowers look they way they look and why they grow where they grow. Then go out and explore. Get close to a flower. Lie in a meadow or crouch in the forest, drape yourself over a boulder on the beach, or bend (carefully!) close to a cactus. Find a bee, beetle, or butterfly on a flower, and become part of its world for a moment. There could be nothing more beautiful on Earth.

❧ SUSAN LAMB

COMMON YELLOW MONKEYFLOWER
*Mimulus guttatus*

Icicles on
Tri-Forest Peak
near Salmon Lake
Trinity Alps Wilderness
Klamath National Forest
Siskiyou County
September 17, 1978

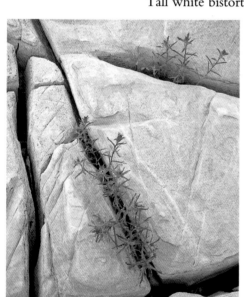

APPLEGATE'S PAINTBRUSH
*Castilleja applegatei* ssp. *pinetorum*

Marble Mountain Wilderness
Klamath National Forest
Siskiyou County
June 22, 1991

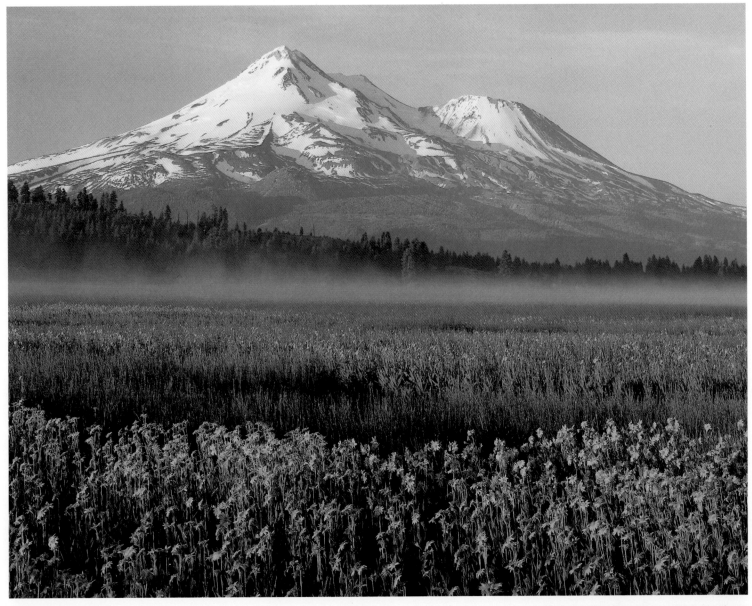

SEEP SPRING ARNICA

*Arnica longifolia*

Highway 97 ~ Grass Lake and Mount Shasta
Cascade Range ~ Siskiyou County
June 12, 1985

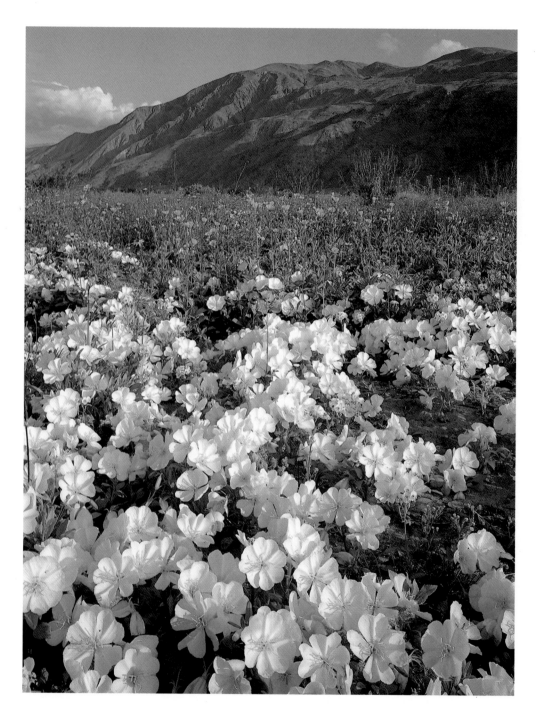

DUNE EVENING PRIMROSE
*Oenothera deltoides* ssp. *deltoides*
DESERT SUNFLOWER
*Geraea canescens*

Henderson Canyon Road
Borrego Valley and Coyote Mountain
Anza–Borrego Desert State Park
Sonoran Desert
San Diego County
March 11, 1992

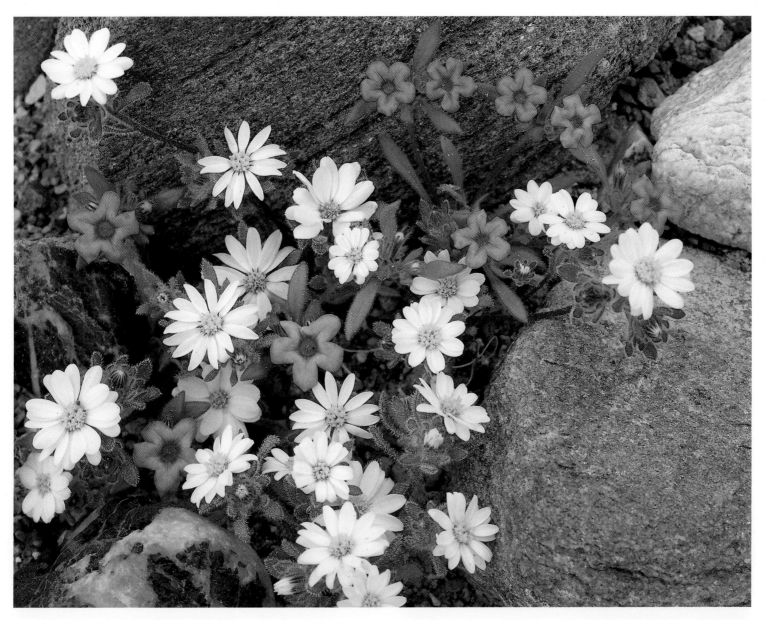

MOJAVE DESERT-STAR  *Monoptilon bellioides*
PURPLE MAT  *Nama demissum* var. *covillei*

Beatty Cutoff ~ Funeral Mountains
Death Valley National Park
Mojave Desert ~ Inyo County
March 7, 1988

35

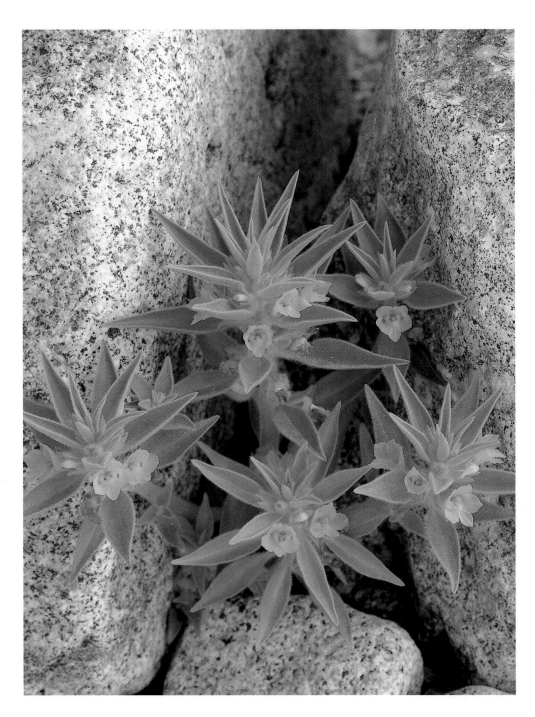

DEATH VALLEY MOHAVEA
*Mohavea breviflora*

Cottonwood Canyon
Death Valley National Park
Mojave Desert ~ Inyo County
March 4, 1988

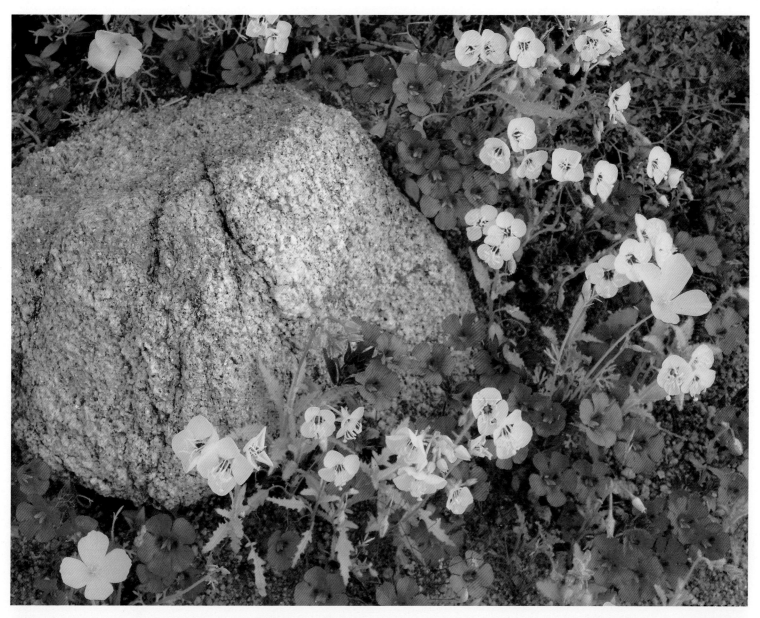

BIGELOW'S MONKEYFLOWER *Mimulus bigelovii* var. *bigelovii*
BROWN-EYED EVENING PRIMROSE *Camissonia claviformis* ssp. *peirsonii*
PARISH'S GOLDPOPPY *Eschscholzia parishii*

Jojoba Wash
Anza-Borrego Desert State Park
Sonoran Desert ~ San Diego County
March 12, 1992

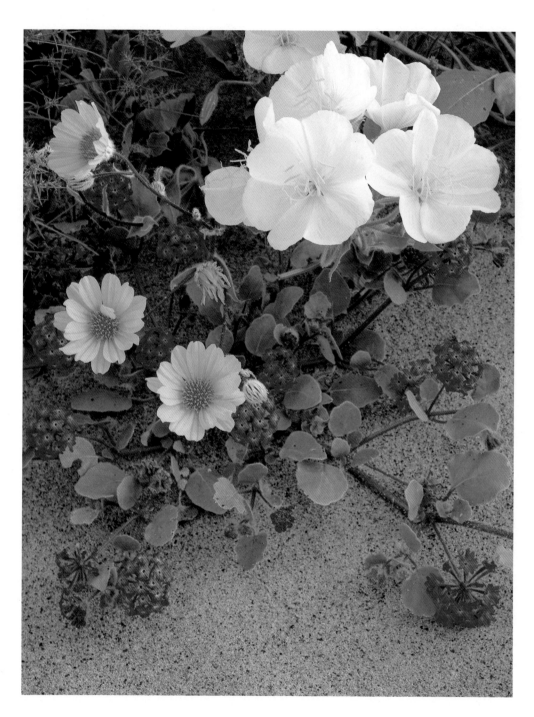

DESERT SAND VERBENA
*Abronia villosa* var. *villosa*
DESERT SUNFLOWER
*Geraea canescens*
DUNE EVENING PRIMROSE
*Oenothera deltoides* ssp. *deltoides*

Henderson Canyon Road
Borrego Valley
Anza–Borrego Desert State Park
Sonoran Desert
San Diego County
March 18, 1992

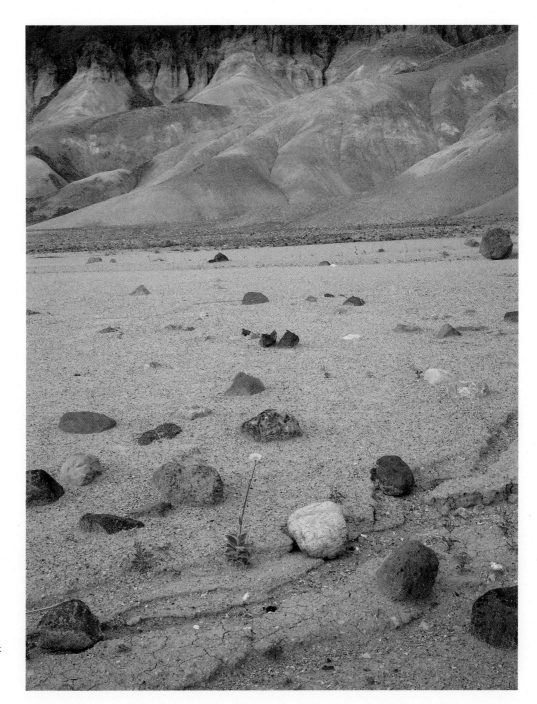

DESERT SUNFLOWER
*Geraea canescens*

Badlands near the mouth
of Golden Canyon
Death Valley National Park
Mojave Desert
Inyo County
March 8, 1988

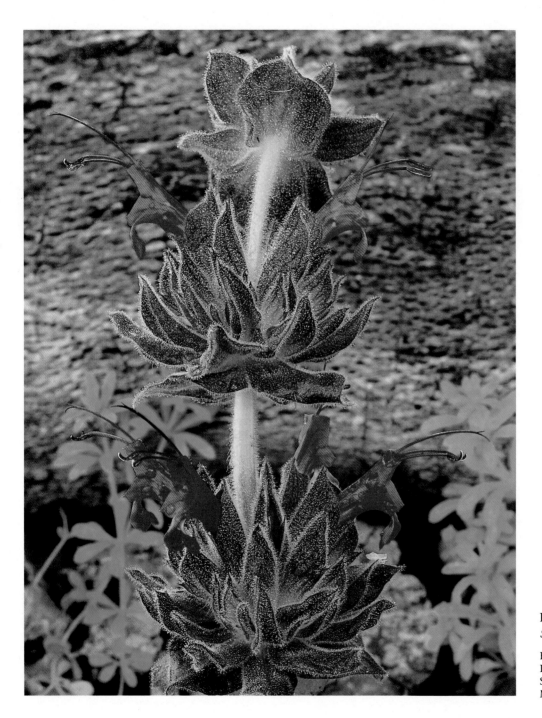

PITCHER SAGE
*Salvia spathacea*

Figueroa Mountain Road
Los Padres National Forest
Santa Barbara County
March 12, 1994

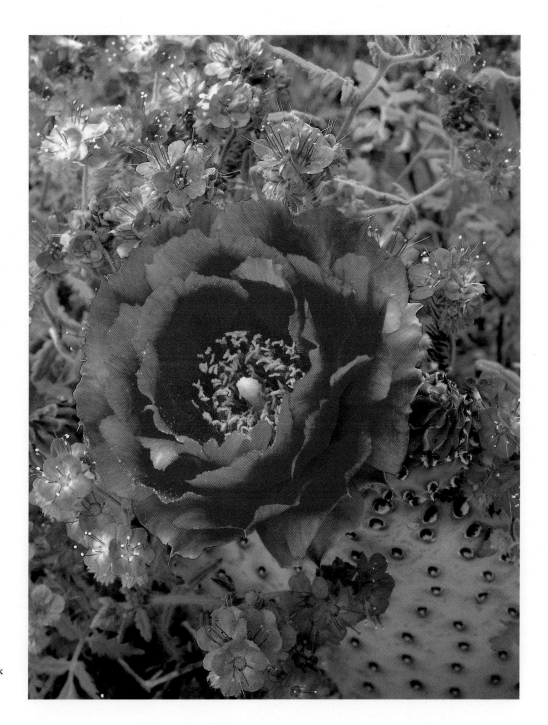

BEAVERTAIL CACTUS
*Opuntia basilaris* var. *basilaris*
COMMON PHACELIA
*Phacelia distans*

Cactus Garden
Anza-Borrego Desert State Park
Sonoran Desert
San Diego County
March 8, 1992

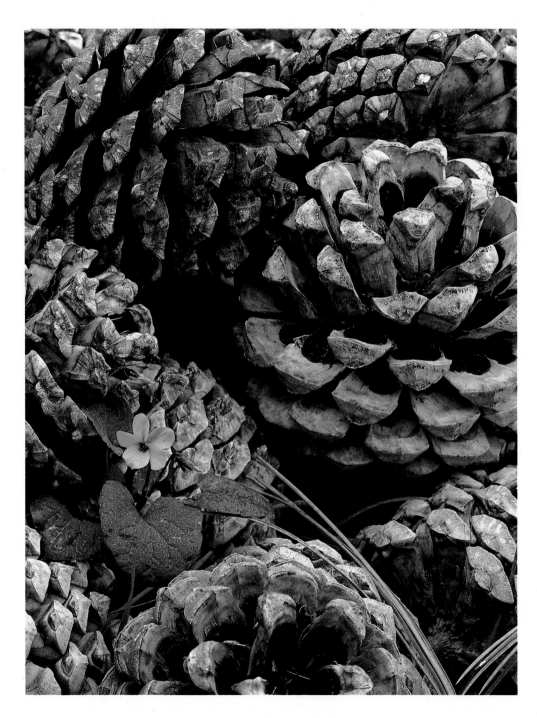

JOHNNY-JUMP-UP
*Viola pedunculata*
TORREY PINE CONES
*Pinus torreyana*

Santa Rosa Island
Channel Islands National Park
Santa Barbara County
March 24, 1990

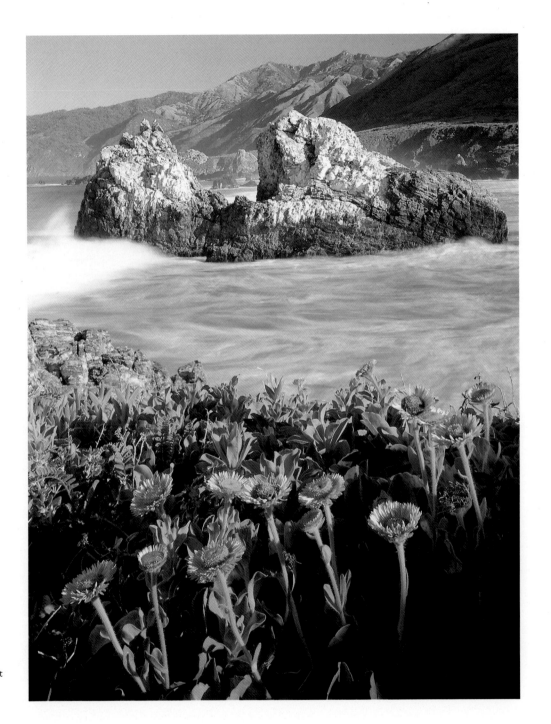

SEASIDE DAISY
*Erigeron glaucus*

Pacific Valley
Santa Lucia Range
Los Padres National Forest
Monterey County
March 12, 1994

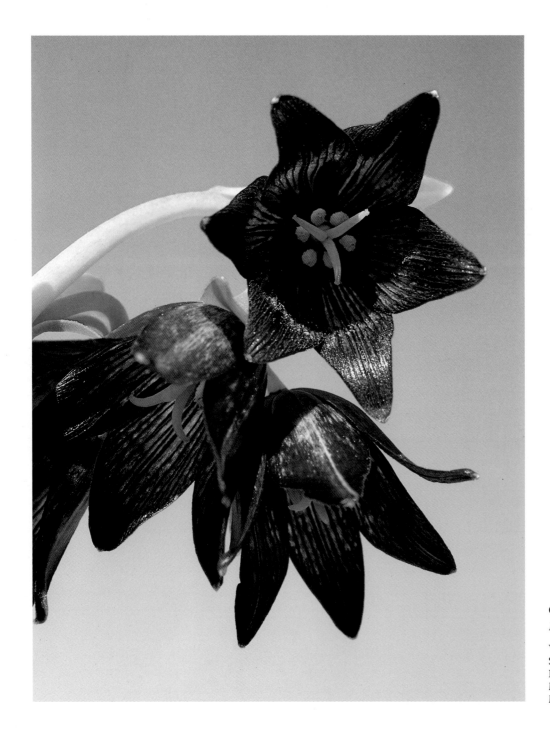

CHOCOLATE LILY
*Fritillaria biflora* var. *biflora*

Willow Creek Road
Santa Lucia Range
Los Padres National Forest
Monterey County
March 12, 1994

44 ❧

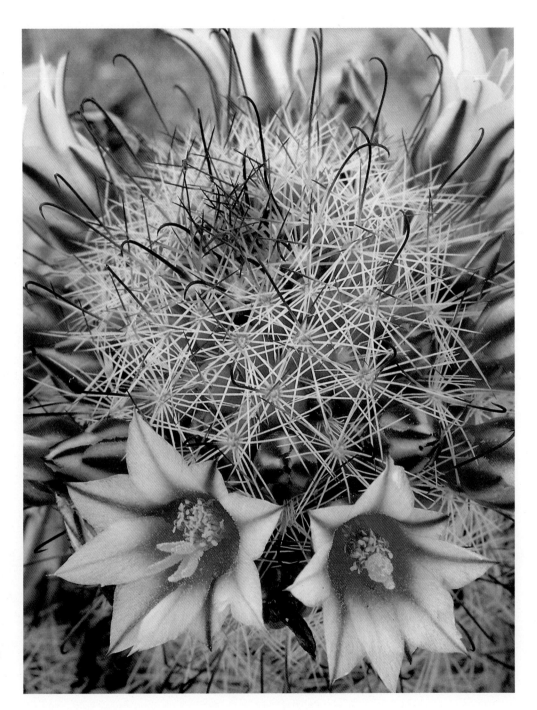

FISH-HOOK CACTUS
*Mammillaria dioica*

Indian Gorge
Anza-Borrego Desert State Park
Sonoran Desert
San Diego County
March 22, 1994

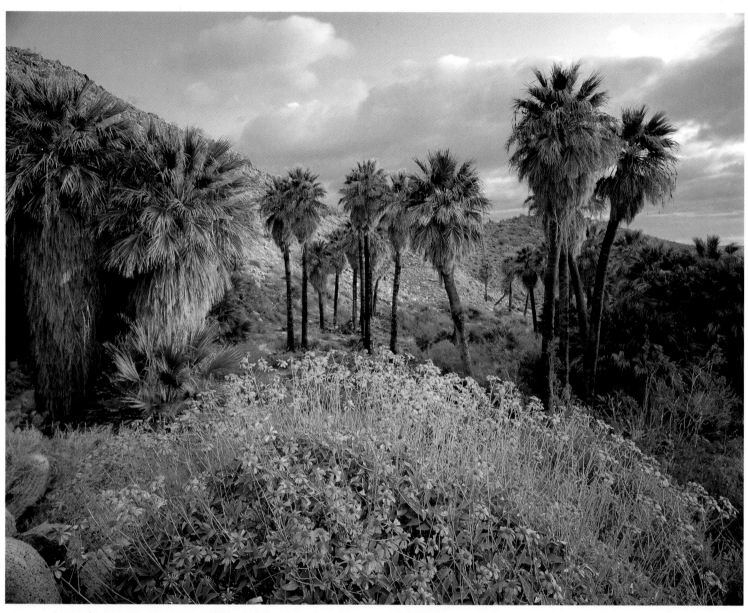

BRITTLEBUSH *Encelia farinosa*
CALIFORNIA FAN PALM *Washingtonia filifera*

Southwest Grove ~ Mountain Palm Springs
Anza–Borrego Desert State Park
Sonoran Desert ~ San Diego County
March 15, 1992

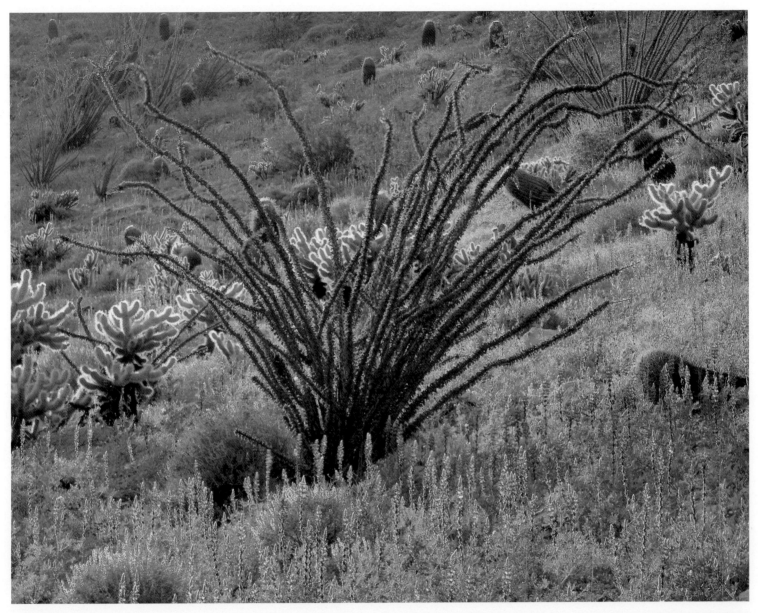

ARIZONA LUPINE *Lupinus arizonicus*
OCOTILLO *Fouquieria splendens* ssp. *splendens*

Vallecito Creek Wash
Anza–Borrego Desert State Park
Sonoran Desert ~ San Diego County
March 25, 1992

47

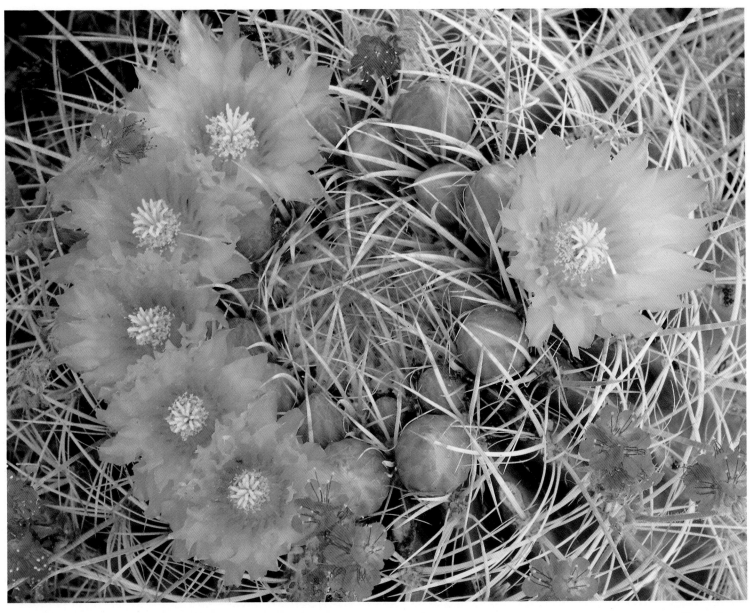

CALIFORNIA BARREL CACTUS  *Ferocactus cylindraceus* var. *cylindraceus*
COMMON PHACELIA  *Phacelia distans*

Cactus Garden
Anza-Borrego Desert State Park
Sonoran Desert ~ San Diego County
March 18, 1992

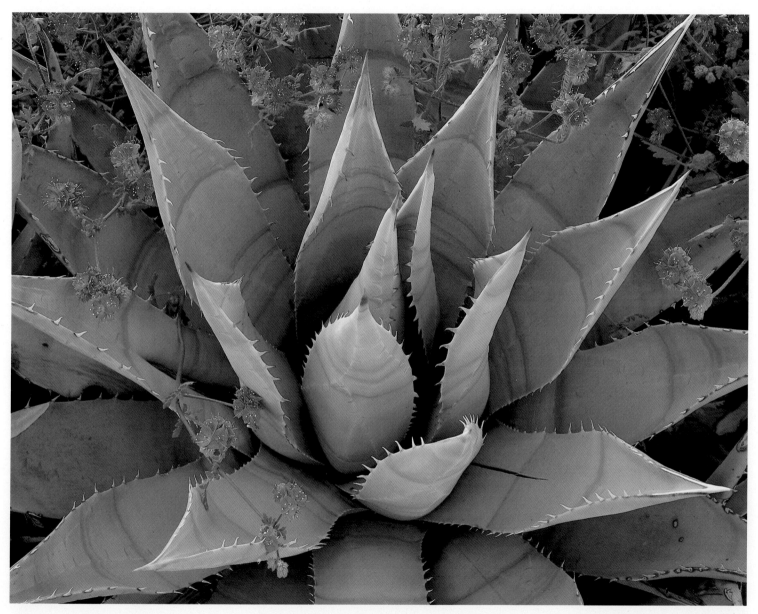

COMMON PHACELIA *Phacelia distans*
DESERT AGAVE *Agave deserti*

Yaqui Meadows near Glorieta Canyon
Anza-Borrego Desert State Park
Sonoran Desert ~ San Diego County
March 19, 1992

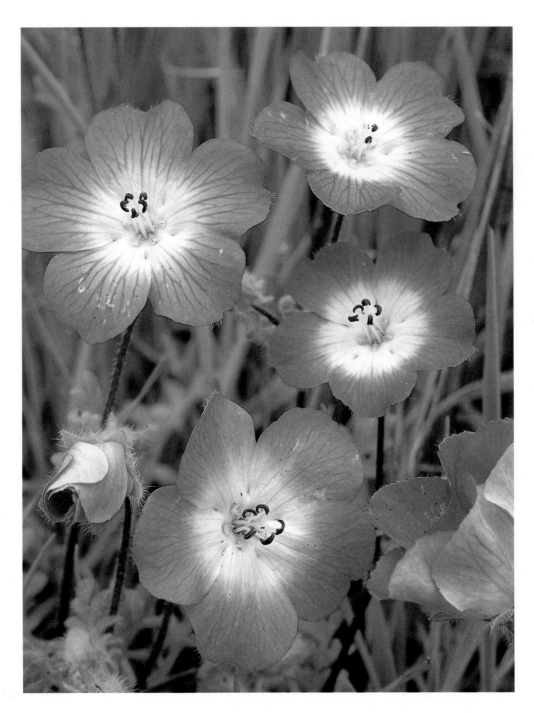

BABY BLUE-EYES

*Nemophilia menziesii* var. *menziesii*

Navajo Creek Valley
Highway 58
South Coast Ranges
San Luis Obispo County
March 16, 1994

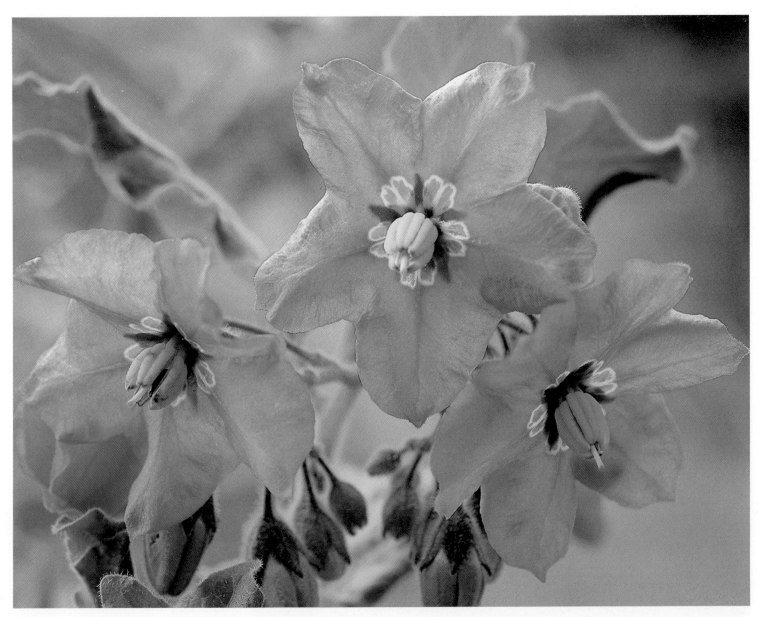

WALLACE'S NIGHTSHADE

*Solanum wallacei*

Cañada Cervada
Nature Conservancy's Santa Cruz Island Preserve
Channel Islands ~ Santa Barbara County
March 20, 1994

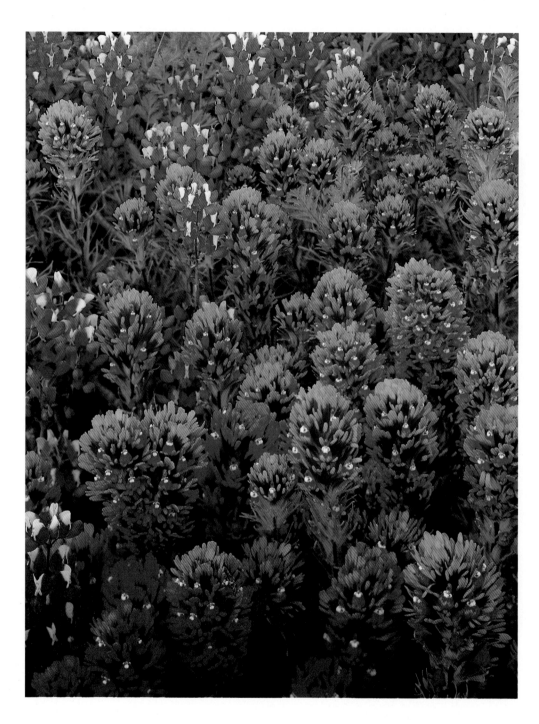

PURPLE OWL'S-CLOVER
*Castilleja exserta* ssp. *exserta*
DOUGLAS' LUPINE
*Lupinus nanus*

San Joaquin Valley
near Grapevine
Kern County
March 25, 1988

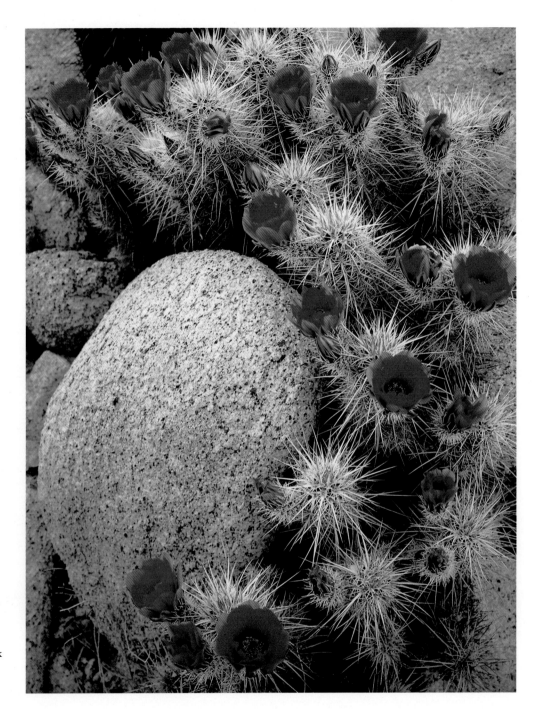

ENGELMANN'S
HEDGEHOG CACTUS
*Echinocereus engelmannii*

Mountain Palm Springs
Anza-Borrego Desert State Park
Sonoran Desert
San Diego County
March 30, 1985

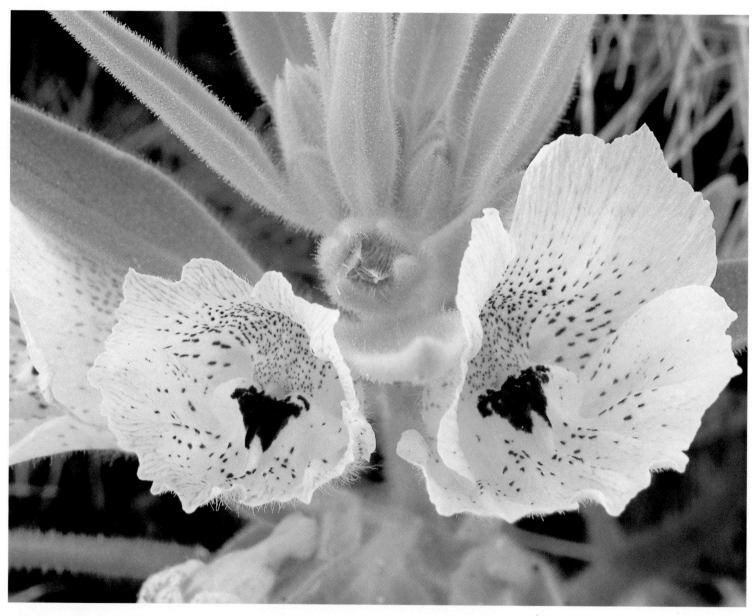

GHOST FLOWER

*Mohavea confertiflora*

<div align="right">

Mountain Palm Springs
Anza–Borrego Desert State Park
Sonoran Desert ~ San Diego County
March 22, 1994

</div>

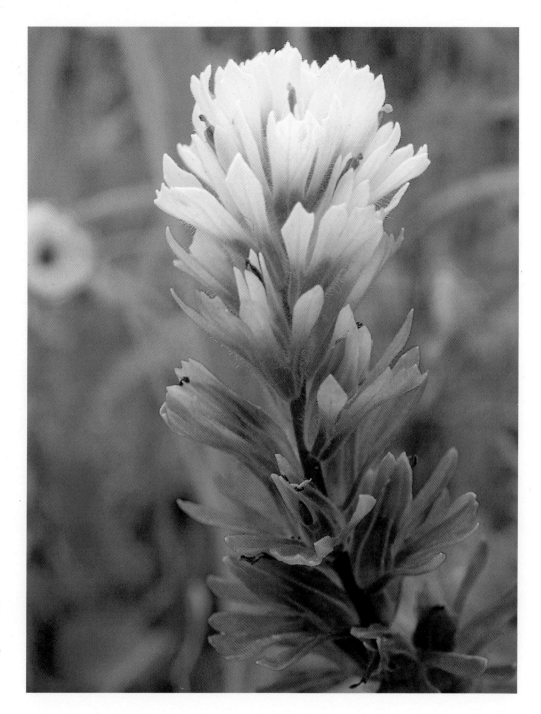

INDIAN PAINTBRUSH
*Castilleja affinis* ssp. *affinis*

Christy Ranch
Nature Conservancy's
Santa Cruz Island Preserve
Channel Islands
Santa Barbara County
March 20, 1994

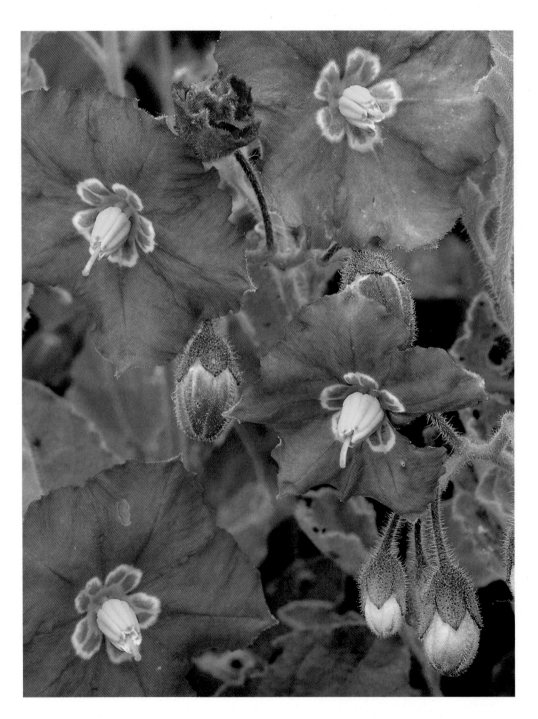

PURPLE NIGHTSHADE

*Solanum xanti*

Snyder Trail
Santa Ynez River Valley
Los Padres National Forest
Santa Barbara County
March 17, 1994

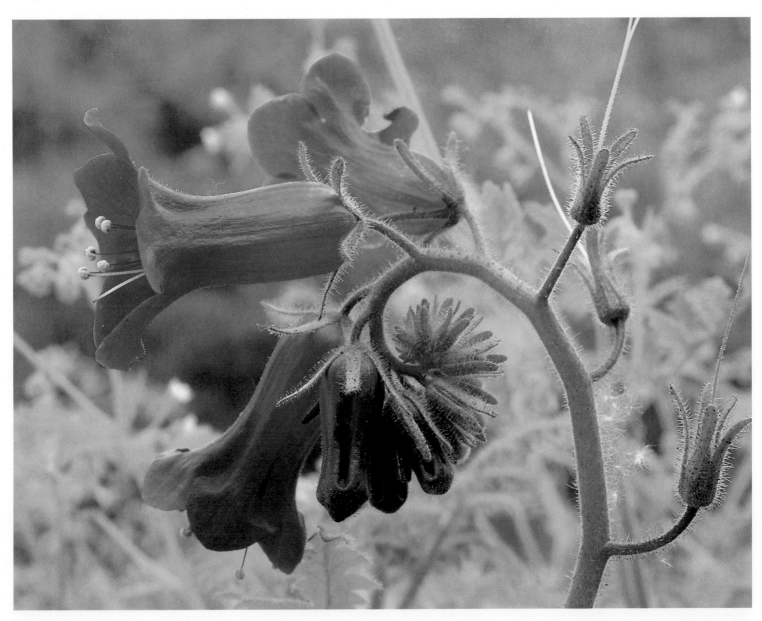

WILD CANTERBURY BELL

*Phacelia minor*

Ortega Highway ~ San Juan Creek Canyon
Santa Ana Mountains ~ Cleveland National Forest
Riverside County
March 23, 1994

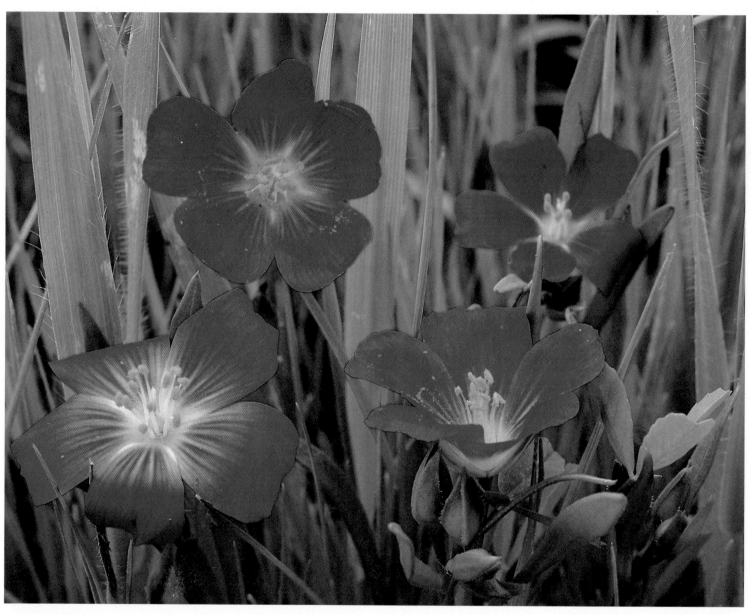

RED MAIDS
*Calandrinia ciliata*

Via Volcano Road ~ Mesa de Colorado
Santa Rosa Plateau Ecological Reserve ~ Riverside County
March 21, 1994

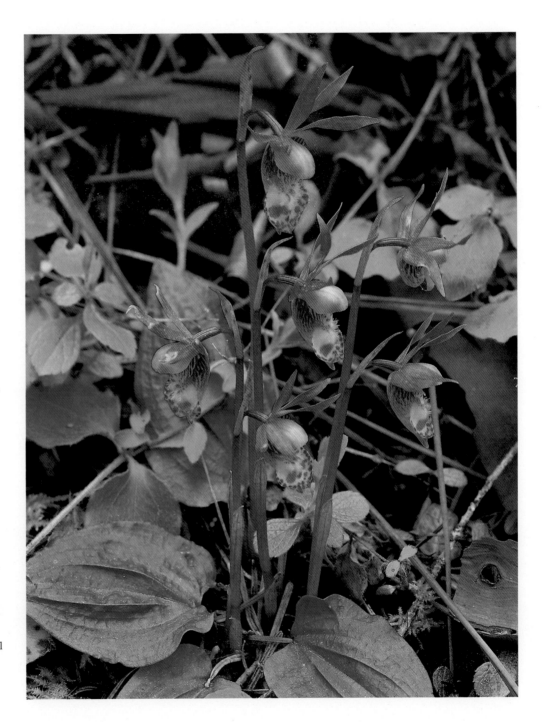

FAIRY SLIPPER
*Calypso bulbosa*

South Kelsey Historical Trail
Siskiyou Mountains
Six Rivers National Forest
Del Norte County
April 6, 1987

INDIAN WARRIOR
*Pedicularis densiflora*
BIG BERRIED MANZANITA
*Arctostaphylos glauca*

High Peaks Trail
Pinnacles National Monument
San Benito County
April 2, 1992

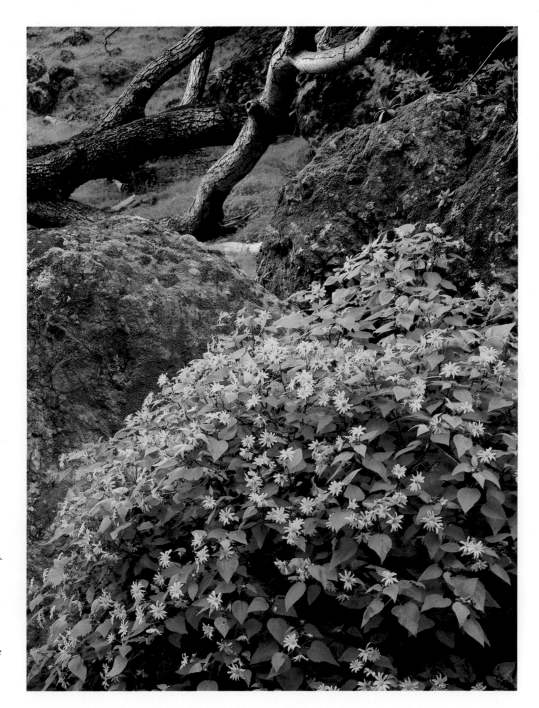

CANYON SUNFLOWER
*Venegasia carpesioides*
BIG-LEAF MAPLE
*Acer macrophyllum*

Platts Harbor
Nature Conservancy's
Santa Cruz Island Preserve
Channel Islands
Santa Barbara County
March 28, 1990

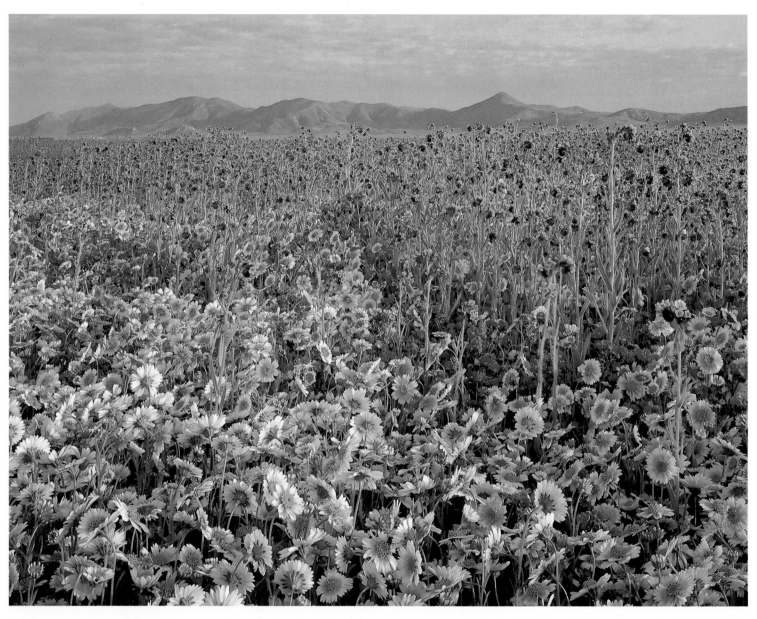

MUNZ' TIDY-TIPS *Layia munzii*
CHINESE LANTERN PHACELIA *Phacelia ciliata*
DEVIL'S LETTUCE *Amsinckia tessellata* var. *tessellata*

Carrizo Plain and Caliente Range near California Valley
San Luis Obispo County
March 29, 1992

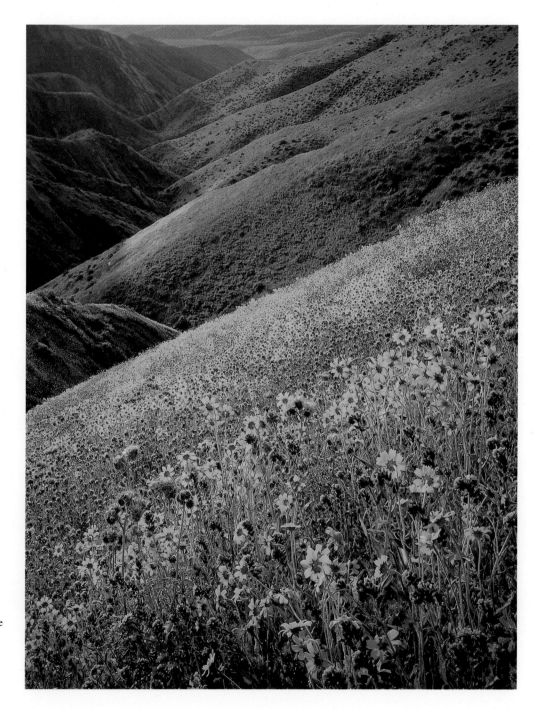

LANCELEAF MONOLOPIA
*Monolopia lanceolata*
TANSYLEAF PHACELIA
*Phacelia tanacetifolia*

Elkhorn Grade Road
Little Signal Hills ~ Temblor Range
Carrizo Plain Natural Area
Bureau of Land Management
Caliente Resource Area
Kern County
April 5, 1992

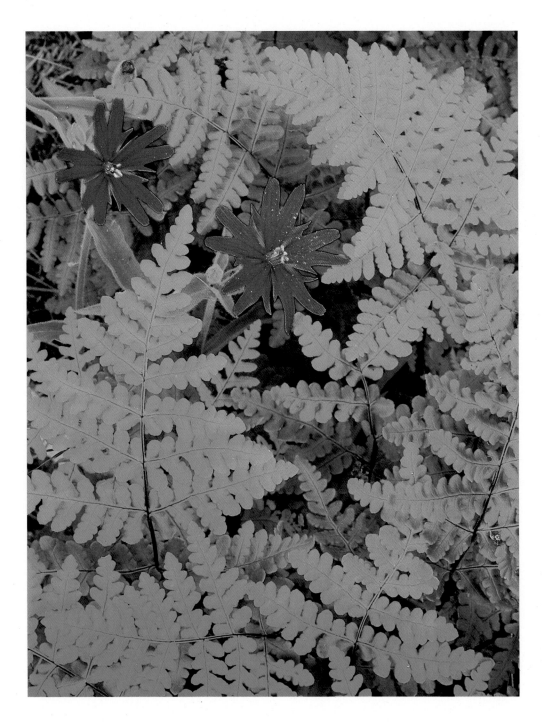

CALIFORNIA CATCHFLY
*Silene californica*
GOLDBACK FERN
*Pentagramma triangularis*

Highway 198
Middle Fork Kaweah River Canyon
Sequoia National Park
Sierra Nevada ~ Tulare County
April 15, 1994

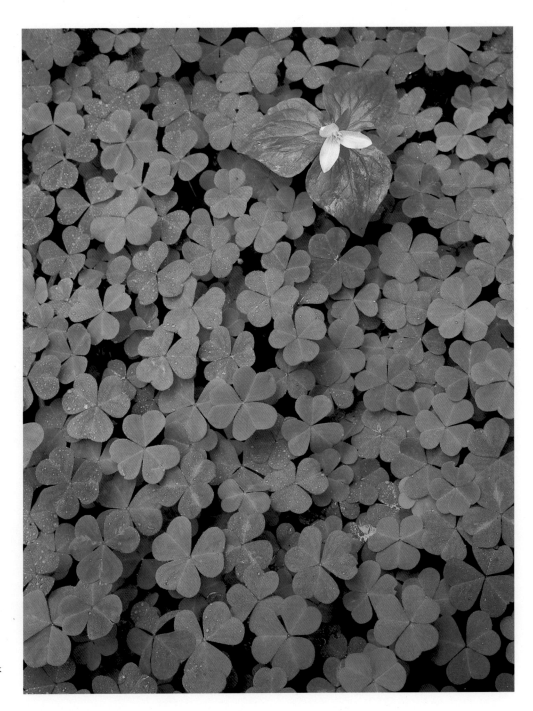

WESTERN TRILLIUM
*Trillium ovatum* ssp. *ovatum*
REDWOOD SORREL
*Oxalis oregana*

Boy Scout Tree Trail
Jedediah Smith Redwoods State Park
Del Norte County
April 6, 1987

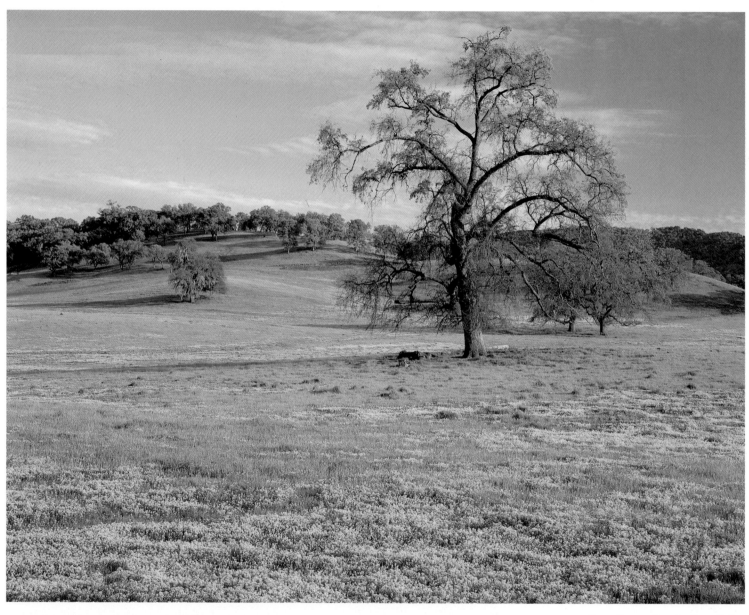

BUTTER-AND-EGGS *Triphysaria eriantha* ssp. *eriantha*
BLUE OAK *Quercus douglasii*

Pope Canyon Road ~ Pope Valley
North Coast Ranges ~ Napa County
April 5, 1994

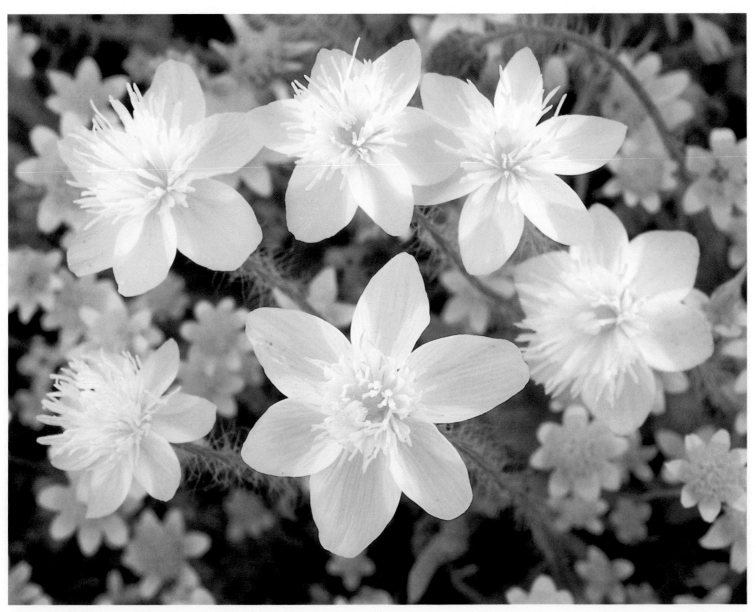

CREAM CUPS *Platystemon californicus*
CALIFORNIA GOLDFIELDS *Lasthenia californica*

Highway 58 ~ Temblor Range
Kern County
April 14, 1994

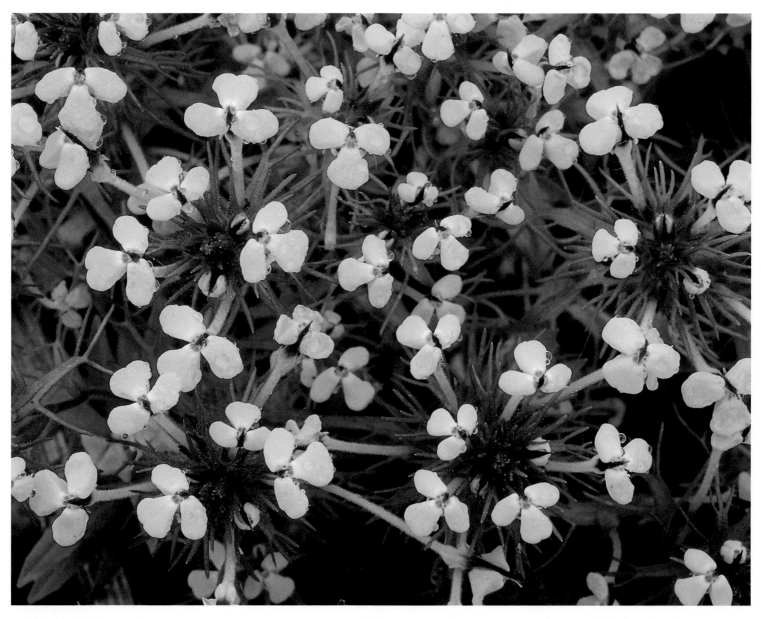

BUTTER-AND-EGGS
*Triphysaria eriantha* ssp. *eriantha*

Nature Conservancy's Willis Linn Jepson Prairie Preserve
Sacramento Valley ~ Solano County
April 5, 1994

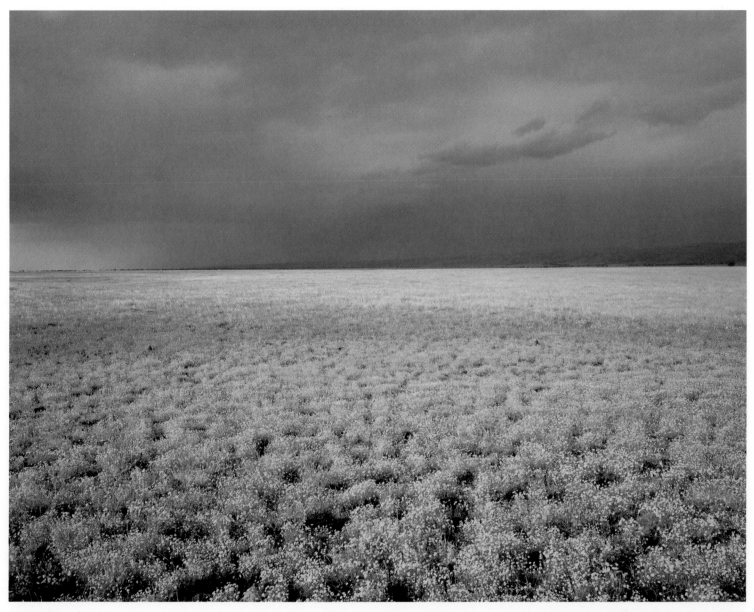

GOLDFIELDS
*Lasthenia glaberrima*

In dry vernal pool ~ Lassen Road ~ Vina Plains
Sacramento Valley ~ Tehama County
April 6, 1994

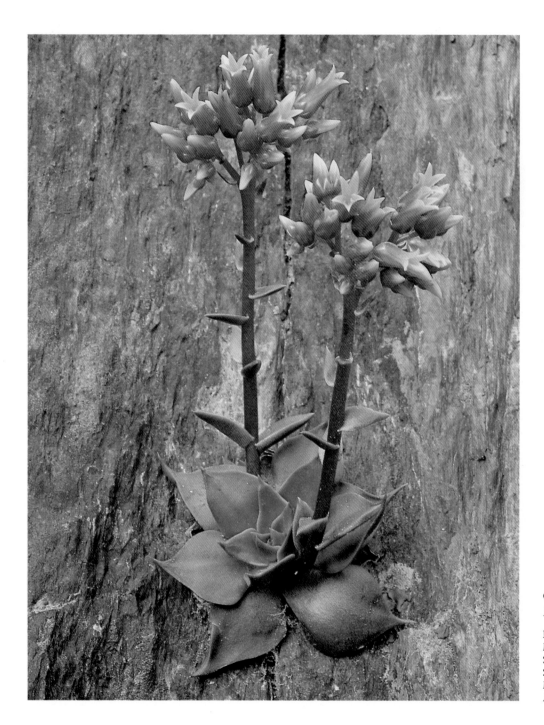

CANYON DUDLEYA
*Dudleya cymosa* ssp. *cymosa*

Highway 140
Merced River Canyon
Sierra National Forest
Sierra Nevada
Mariposa County
April 12, 1994

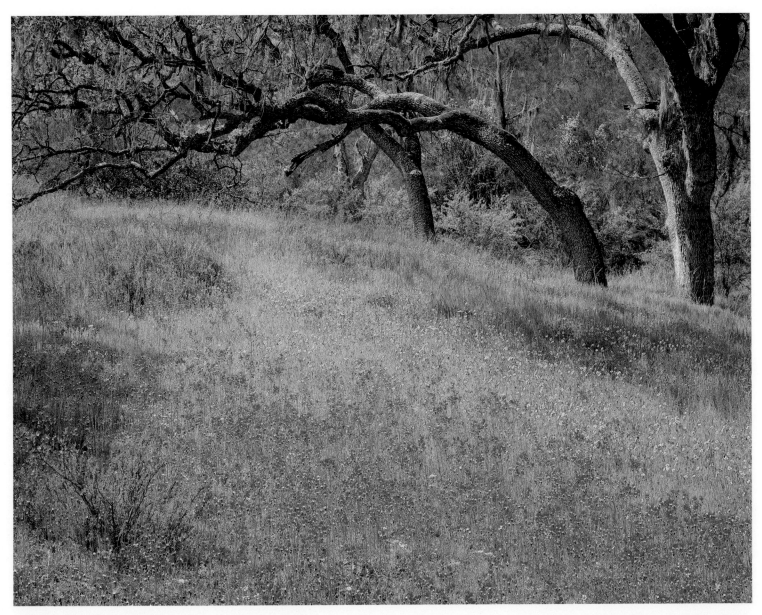

PADRES' SHOOTING STAR *Dodecatheon clevelandii* ssp. *patulum*
JOHNNY-JUMP-UP *Viola pedunculata*
BLUE OAK *Quercus douglasii*

Near Chaparral ~ Gabilan Range
Pinnacles National Monument ~ San Benito County
April 7, 1992

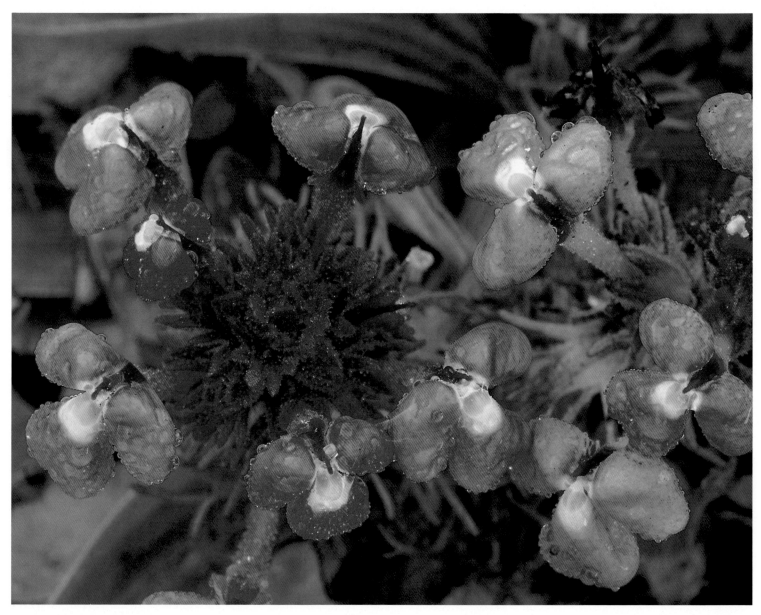

ROSY BUTTER-AND-EGGS
*Triphysaria eriantha* ssp. *rosea*

Salt Point ~ Salt Point State Park
Sonoma County
April 4, 1994

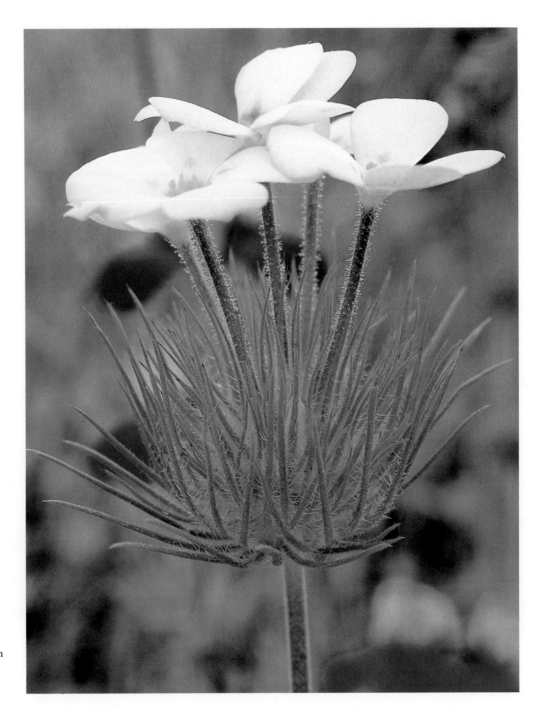

MUSTANG CLOVER
*Linanthus montanus*

White Rock Road
Mariposa Creek Canyon
Sierra Nevada Foothills
Mariposa County
April 13, 1994

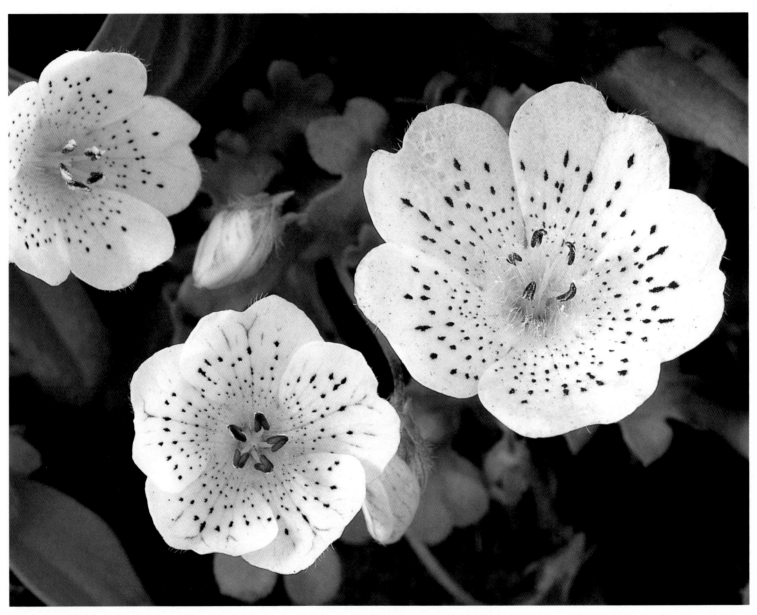

BABY BLUE-EYES
*Nemophila menziesii* var. *atomaria*

McClures Beach ~ Point Reyes National Seashore
Marin County
April 5, 1994

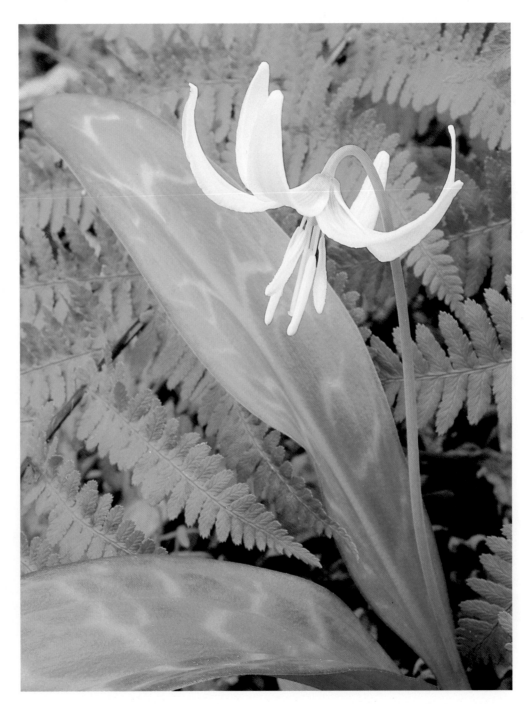

CALIFORNIA FAWN LILY
*Erythronium californicum*
WOOD FERN
*Dryopteris arguta*

Highway 36
Six Rivers National Forest
North Coast Ranges
Humboldt County
April 9, 1994

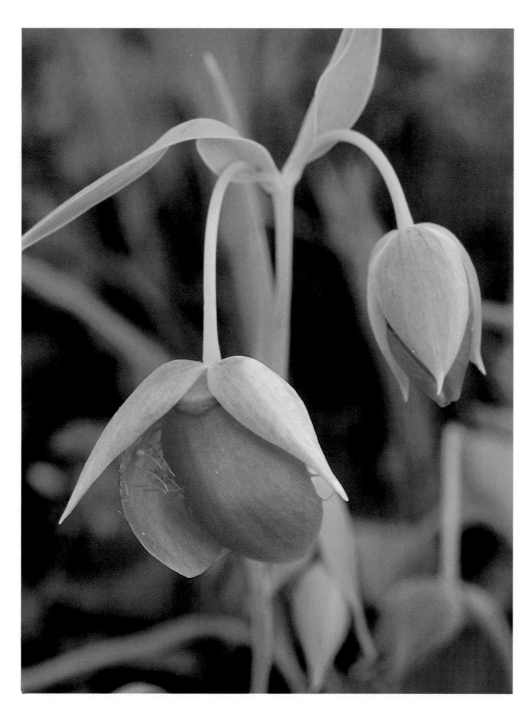

Rosy fairy lantern
*Calochortus amoenus*

Highway 198
Middle Fork Kaweah River Canyon
Sequoia National Park
Sierra Nevada
Tulare County
April 15, 1994

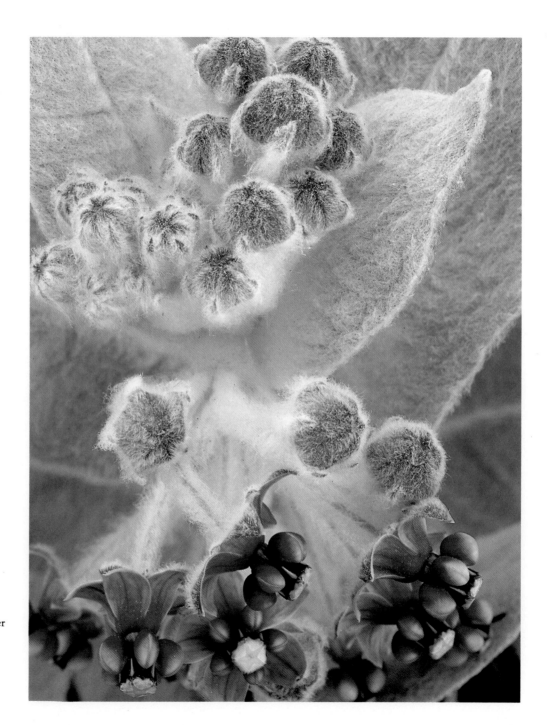

CALIFORNIA MILKWEED
*Asclepias californica*

Merced Wild and Scenic River
Recreation Area
Bureau of Land Management
Folsom Resource Area
Sierra Nevada Foothills
Mariposa County
April 13, 1994

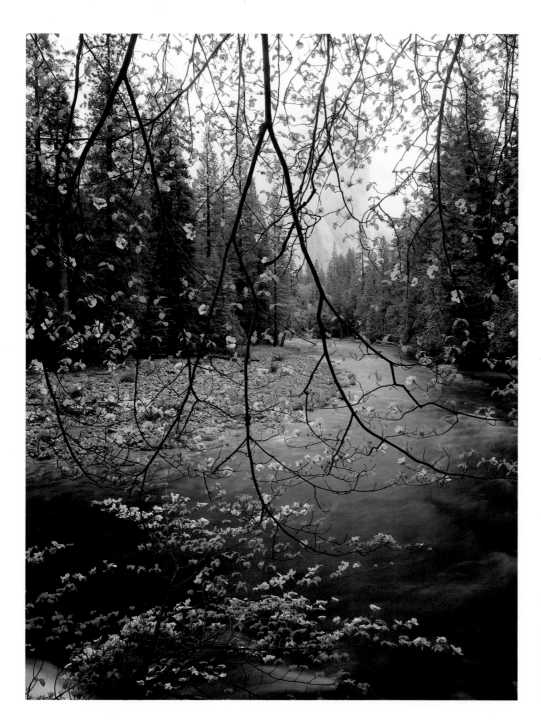

MOUNTAIN DOGWOOD
*Cornus nuttallii*

Merced River
Yosemite Valley
Yosemite National Park
Sierra Nevada
Mariposa County
April 19, 1988

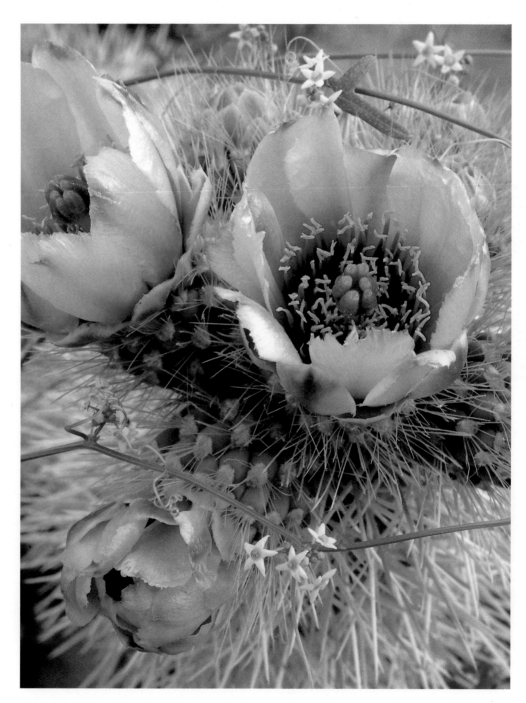

TEDDY-BEAR CHOLLA
*Opuntia bigelovii*
BIGELOW'S BRANDEGEA
*Brandegea bigelovii*

Cholla Garden
Joshua Tree National Park
Mojave Desert
Riverside County
April 22, 1984

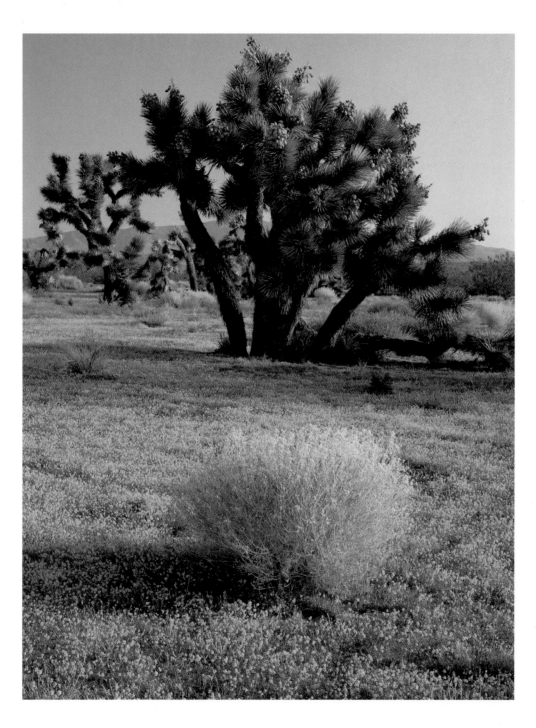

CALIFORNIA GOLDFIELDS
*Lasthenia californica*
JOSHUA TREE
*Yucca brevifolia*

Antelope Valley
Mojave Desert
Kern County
April 27, 1986

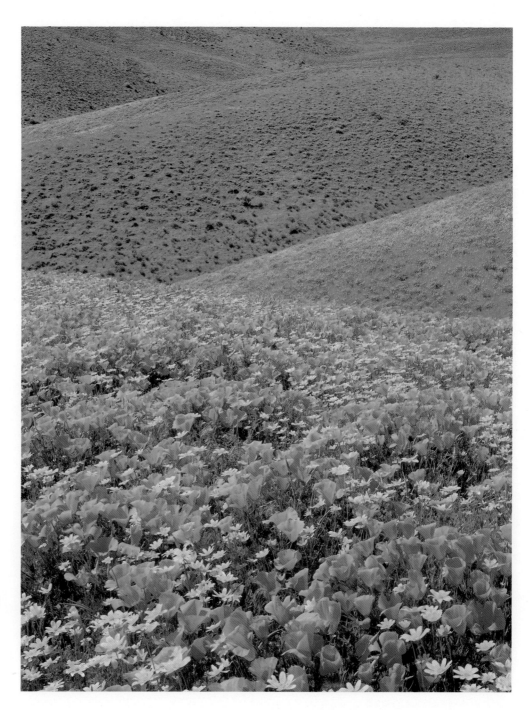

CALIFORNIA POPPY
*Eschscholzia californica*
CALIFORNIA COREOPSIS
*Coreopsis californica*

Portal Ridge
Antelope Valley
Mojave Desert
Los Angeles County
April 26, 1986

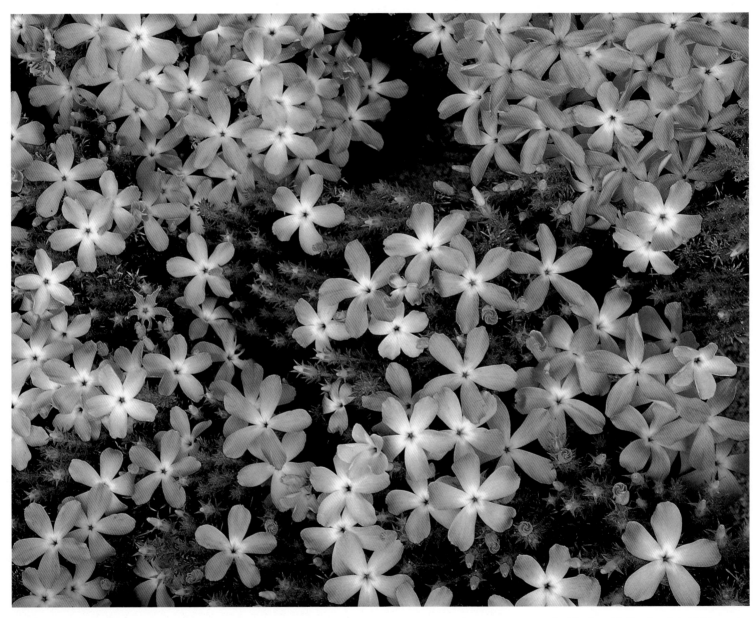

PRICKLY PHLOX

*Leptodactylon californicum*

Pacific Crest Trail ~ San Gabriel Mountains
Angeles National Forest ~ Los Angeles County
April 25, 1990

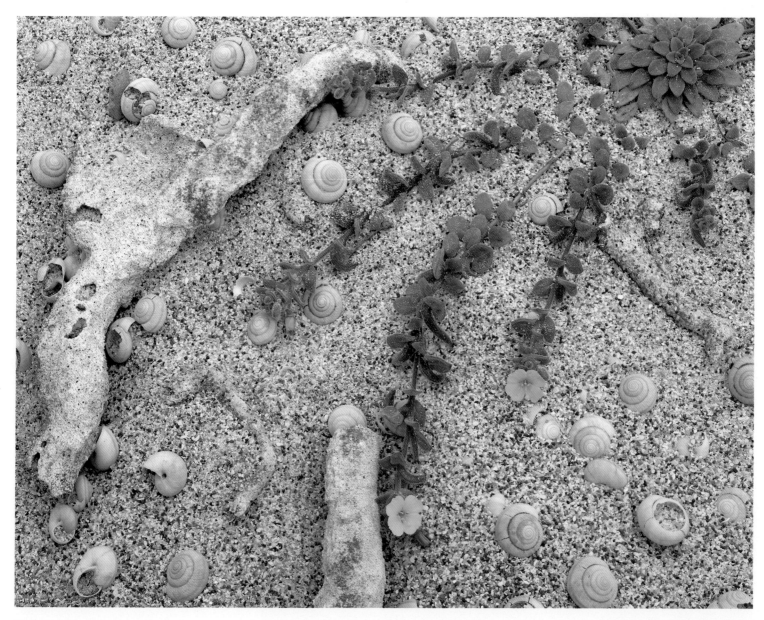

BEACH EVENING PRIMROSE
*Camissonia cheiranthifolia* ssp. *cheiranthifolia*
~ WITH CALICHE AND AYRES' SNAIL SHELLS

Point Bennett ~ San Miguel Island
Channel Islands National Park
Santa Barbara County
April 27, 1990

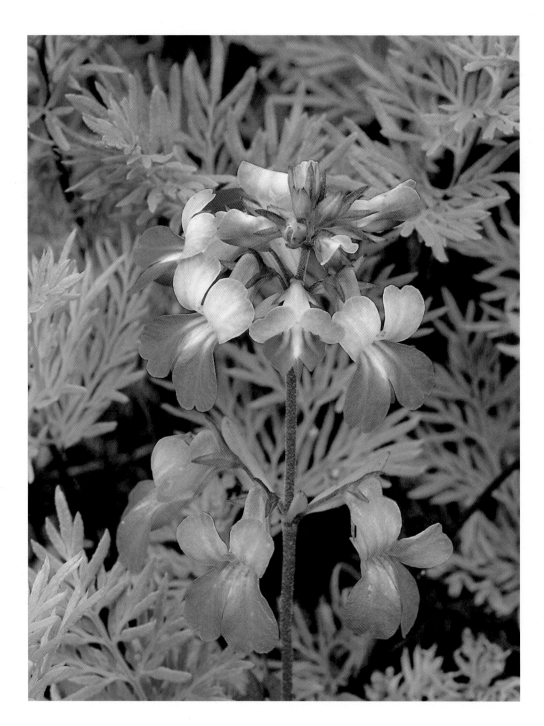

GIANT BLUE-EYED MARY
*Collinsia grandiflora*
INDIAN DREAM
*Aspidotis densa*

Cecilville Road
Middle Fork Salmon River Canyon
Salmon Mountains
Klamath National Forest
Siskiyou County
May 9, 1993

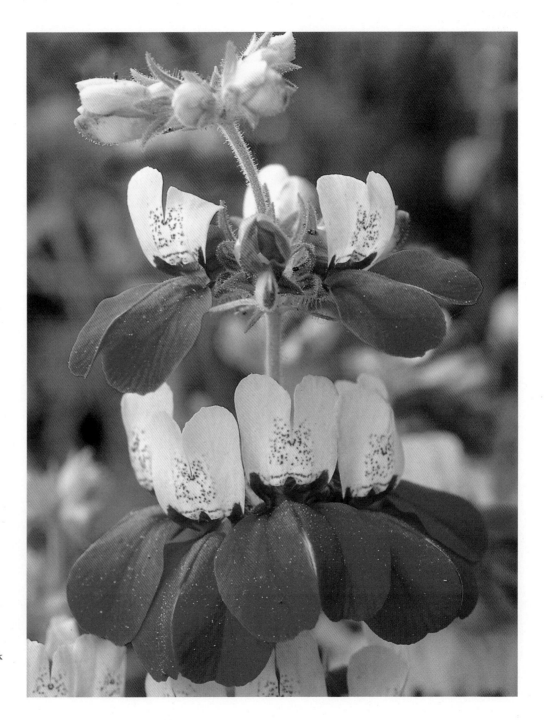

CHINESE HOUSES

*Collinsia heterophylla*

Highway 49 near Sutter Creek
Sierra Nevada Foothills
Amador County
April 19, 1994

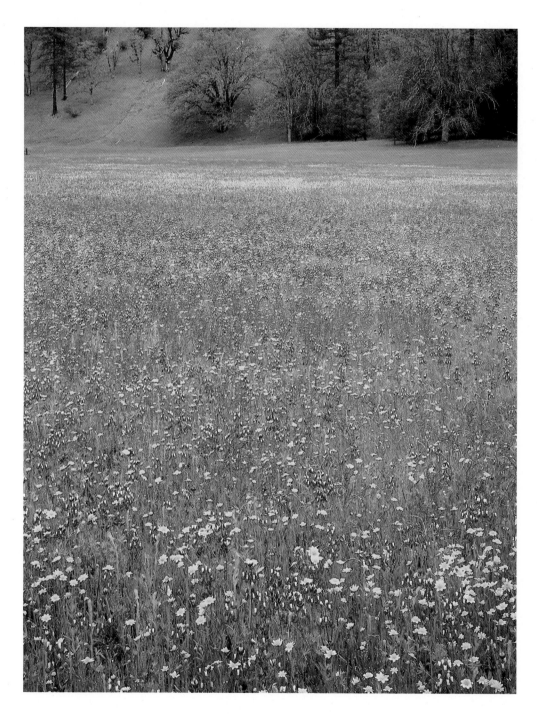

DOUGLAS' LUPINE
*Lupinus nanus*
CALIFORNIA GOLDFIELDS
*Lasthenia californica*
SHEEP SORREL
*Rumex Acetosella ~ alien species*

Mad River Valley near Ruth
Six Rivers National Forest
Trinity County
May 6, 1982

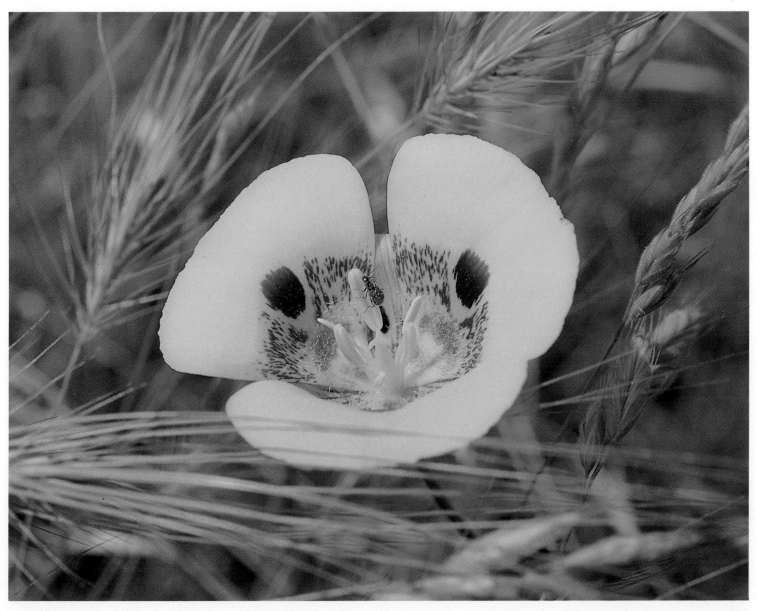

GOLD NUGGETS
*Calochortus luteus*

Masten Road ~ Sacramento Valley
Tehama County
May 8, 1993

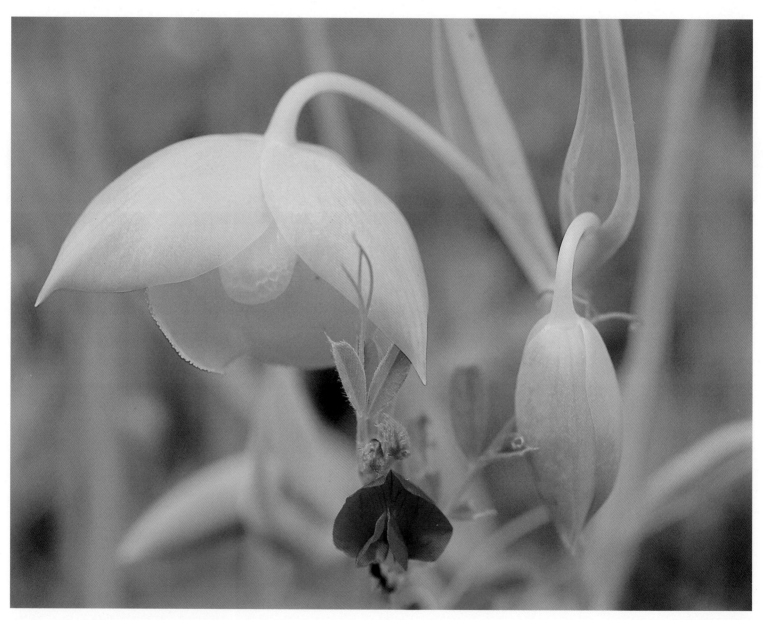

DIOGENES LANTERN *Calochortus amabilis*
COMMON VETCH *Vicia sativa* ssp. *nigra ~ alien species*

Alderpoint Road ~ North Coast Ranges
Humboldt County
May 7, 1993

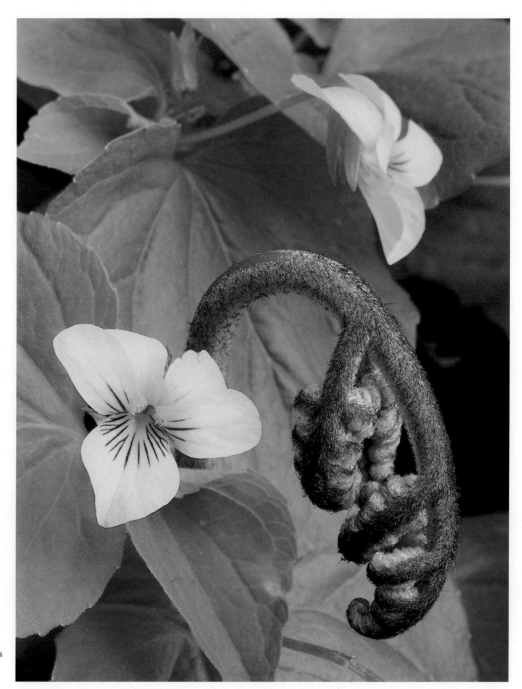

STREAM VIOLET
*Viola glabella*
BRACKEN
*Pteridium aquilinum*
var. *pubescens*

Kneeland Road
North Coast Ranges
Humboldt County
May 7, 1993

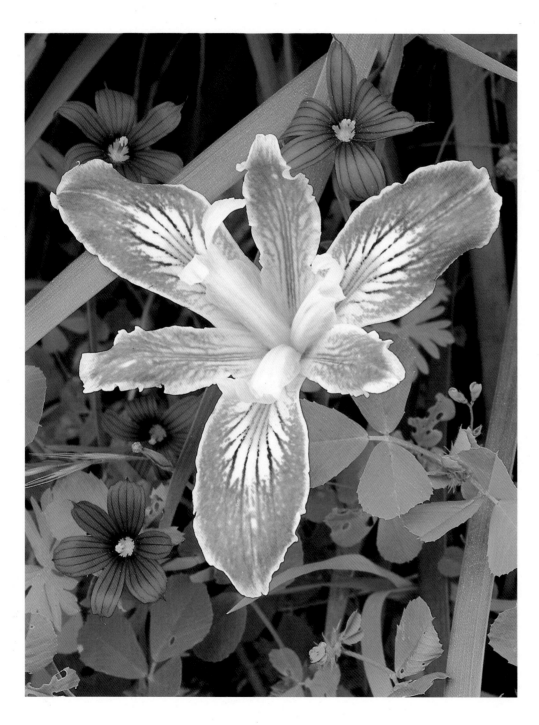

LONG–TUBED IRIS
*Iris tenuissima* ssp. *tenuissima*
BLUE–EYED GRASS
*Sisyrinchium bellum*

Kneeland Road
North Coast Ranges
Humboldt County
May 7, 1993

WHISKER BRUSH  *Linanthus ciliatus*
SIERRA LAYIA *Layia  pentachaeta* ssp. *pentachaeta*

Kings Canyon Road ~ Kings River Canyon
Sierra National Forest ~ Sierra Nevada ~ Fresno County
May 27, 1993

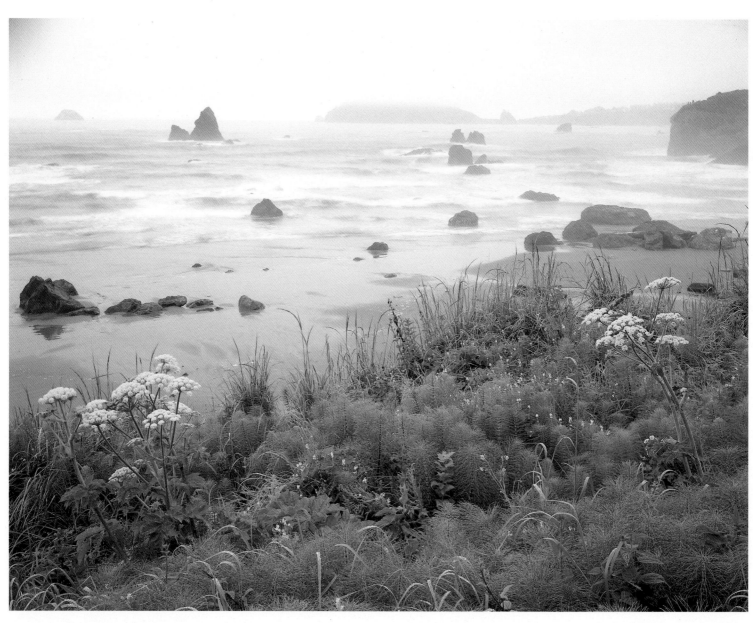

COW PARSNIP  *Heracleum lanatum*
COAST MAN–ROOT  *Marah oreganus*
COMMON HORSETAIL  *Equisetum arvense*

Scenic Drive ~ Houda Point Beach ~ Humboldt North Coast Land Trust
Trinidad ~ Humboldt County
May 12, 1984

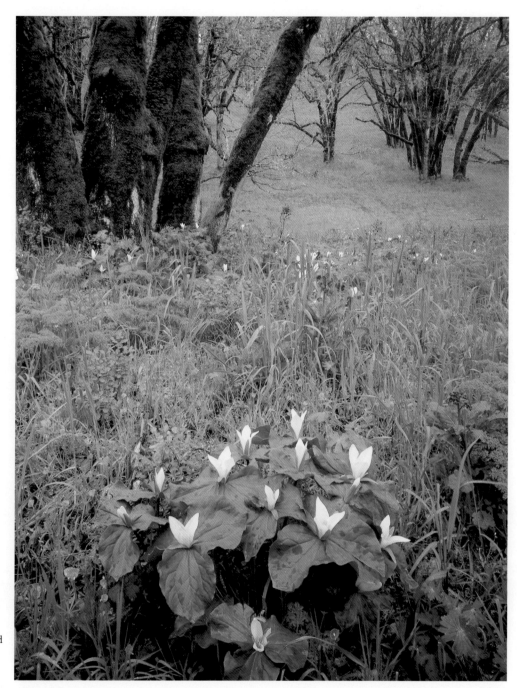

WHITE TRILLIUM
*Trillium albidum*
OREGON OAK
*Quercus garryana*

Redwood House Road
North Coast Ranges
Humboldt County
May 10, 1983

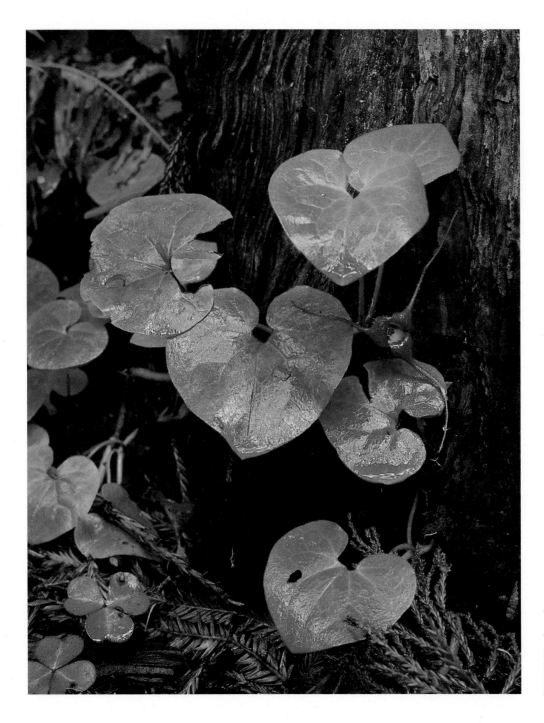

WILD GINGER
*Asarum caudatum*

Damnation Creek Trail
Del Norte Coast Redwoods State Park
Del Norte County
May 12, 1979

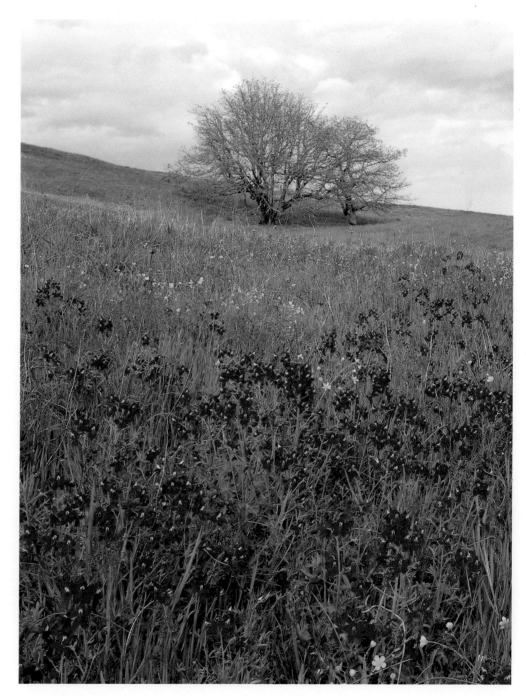

TRACY'S LARKSPUR
*Delphinium decorum* ssp. *tracyi*
WESTERN BUTTERCUP
*Ranunculus occidentalis*
SHEEP SORREL
*Rumex acetosella ~ alien species*
OREGON OAK
Quercus garryana

Bald Hills Road
Schoolhouse Peak
Redwood National Park
Humboldt County
May 6, 1987

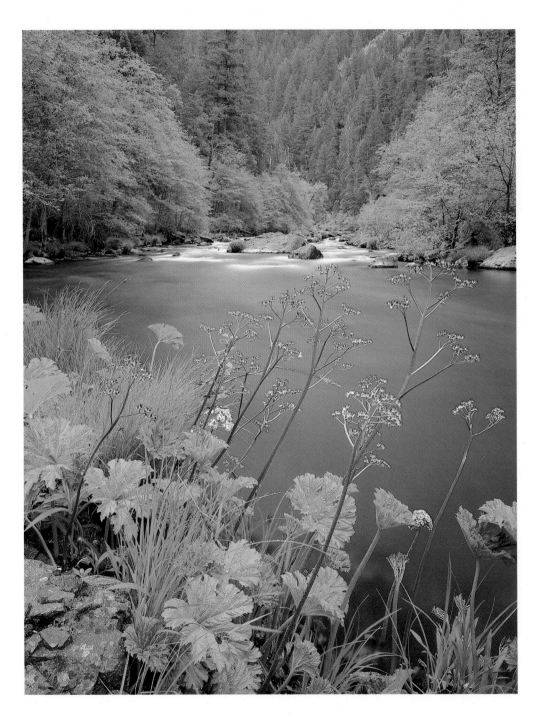

INDIAN RHUBARB
*Darmera peltata*

McCloud River
Nature Conservancy's
McCloud River Preserve
Cascade Range
Shasta County
May 14, 1993

WESTERN REDBUD
*Cercis occidentalis*

Middle Fork Salmon River ~ Cecilville Road ~ Salmon Mountains
Klamath National Forest ~ Siskiyou County
May 9, 1993

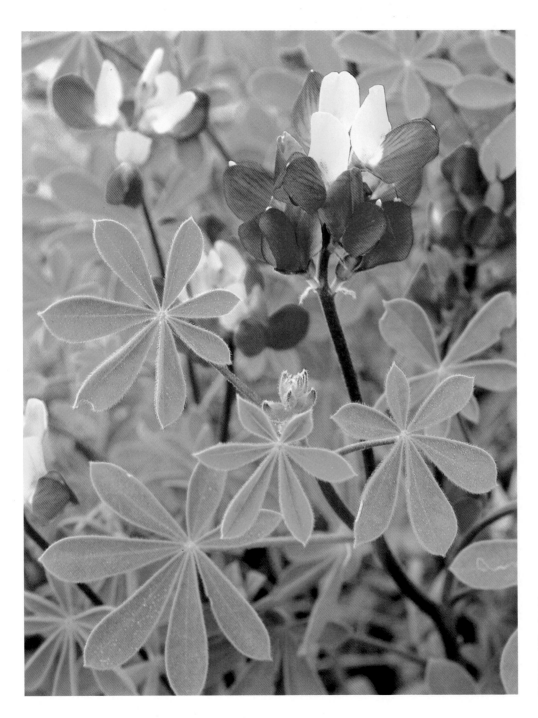

HARLEQUIN LUPINE
*Lupinus stiversii*

Highway 120
Yosemite National Park
Sierra Nevada
Mariposa County
May 24, 1993

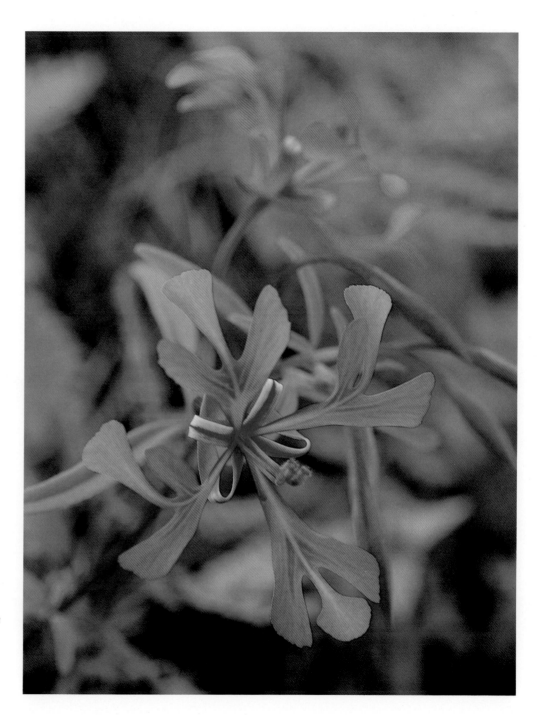

RED RIBBONS
*Clarkia concinna* ssp. *concinna*

Highway 299
Trinity River Canyon
Six Rivers National Forest
Trinity County
May 23, 1993

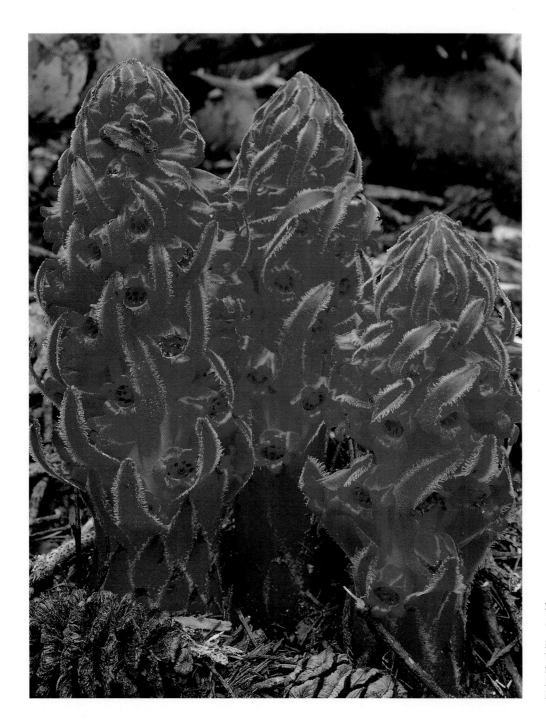

SNOW PLANT
*Sarcodes sanguinea*

Mariposa Grove
Yosemite National Park
Sierra Nevada
Mariposa County
May 27, 1987

MOUNTAIN PRIDE
*Penstemon newberryi* var. *newberryi*
FERN–LEAVED LOMATIUM
*Lomatium dissectum* var. *multifidum*

Alta Trail ~ Giant Forest
Sequoia National Park
Sierra Nevada
Tulare County
May 26, 1987

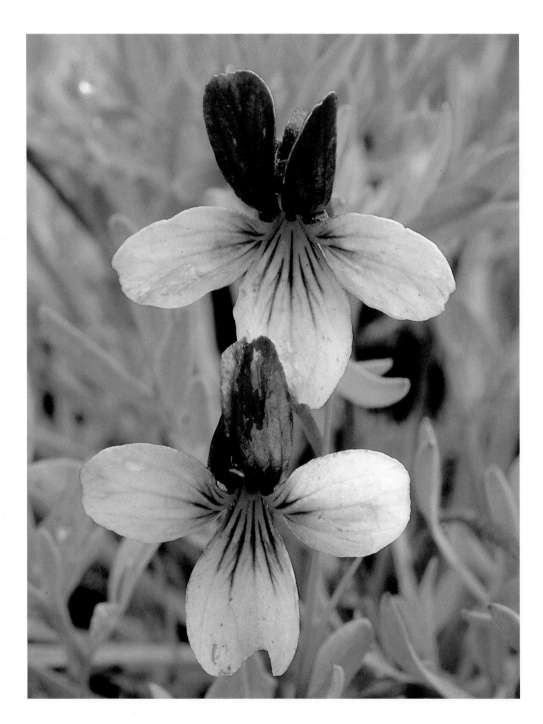

GREAT BASIN VIOLET
*Viola beckwithii*

Forest Road 105
Pine Creek Valley
Lassen National Forest
Cascade Range
Lassen County
June 5, 1993

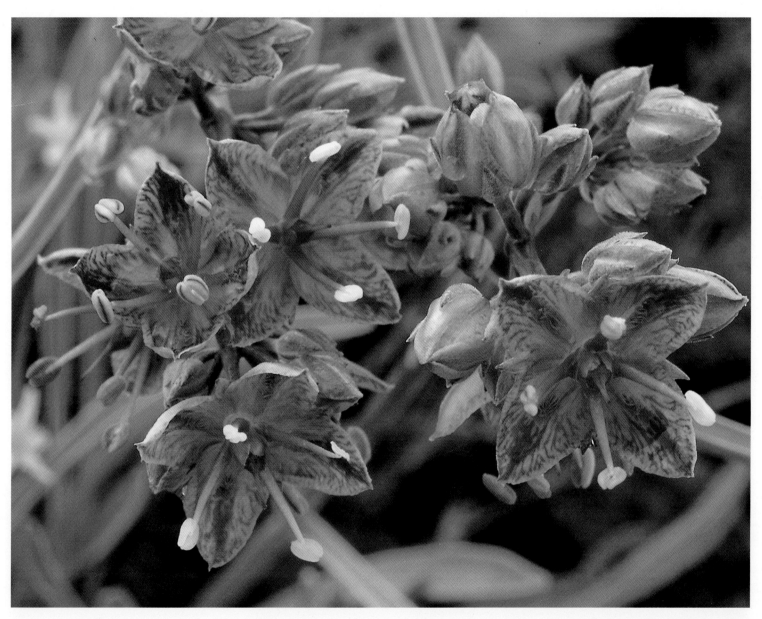

WHITESTEM SWERTIA
*Swertia albicaulis* var. *albicaulis*

Highway 139 ~ Grasshopper Valley
Modoc Plateau ~ Lassen County
June 5, 1993

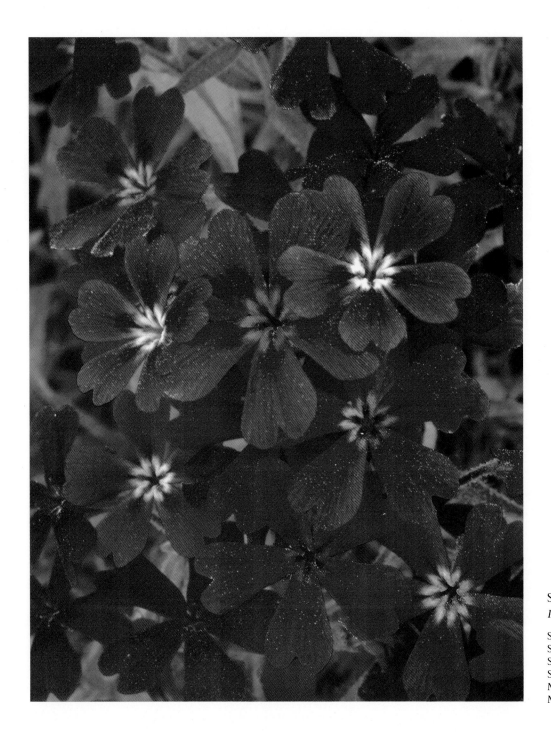

SHOWY PHLOX
*Phlox speciosa* ssp. *occidentalis*

Sierra Vista National Scenic Byway
San Joaquin River Canyon
Sierra National Forest
Sierra Nevada
Madera County
May 25, 1993

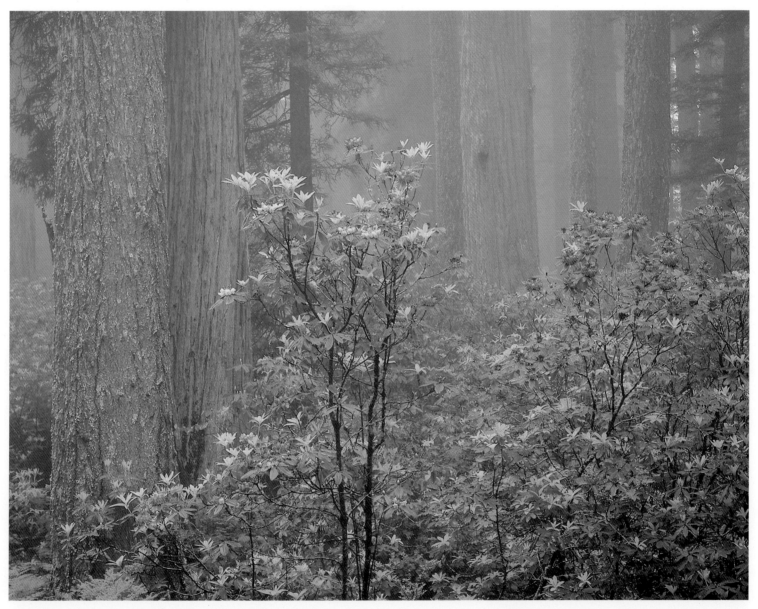

CALIFORNIA ROSE-BAY  *Rhododendron macrophyllum*
DOUGLAS-FIR  *Pseudotsuga menziesii*
REDWOOD  *Sequoia sempervirens*

Highway 101 ~ Del Norte Coast Redwoods State Park
Del Norte County
May 21, 1993

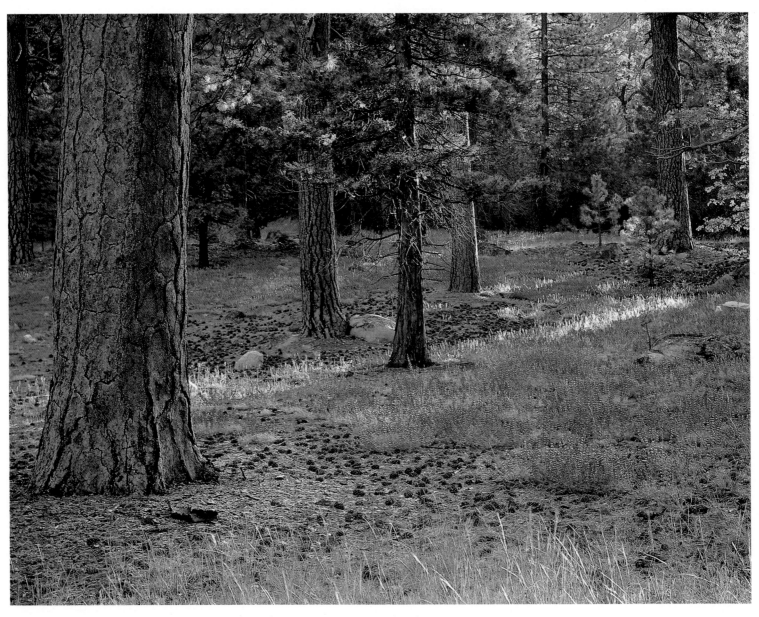

SIERRA LUPINE   *Lupinus grayii*
PACIFIC PONDEROSA PINE   *Pinus ponderosa*

Kings Canyon ~ Kings Canyon National Park
Sierra Nevada ~ Fresno County
May 27, 1993

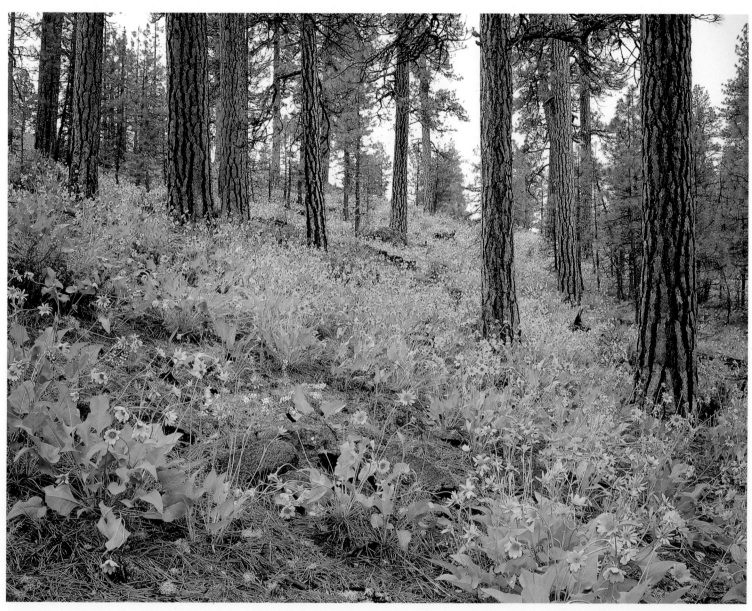

DELTOID BALSAM-ROOT  *Balsamorhiza deltoidea*
PACIFIC PONDEROSA PINE  *Pinus ponderosa*

Forest Road 85 ~ Modoc National Forest
Modoc Plateau ~ Modoc County
June 4, 1993

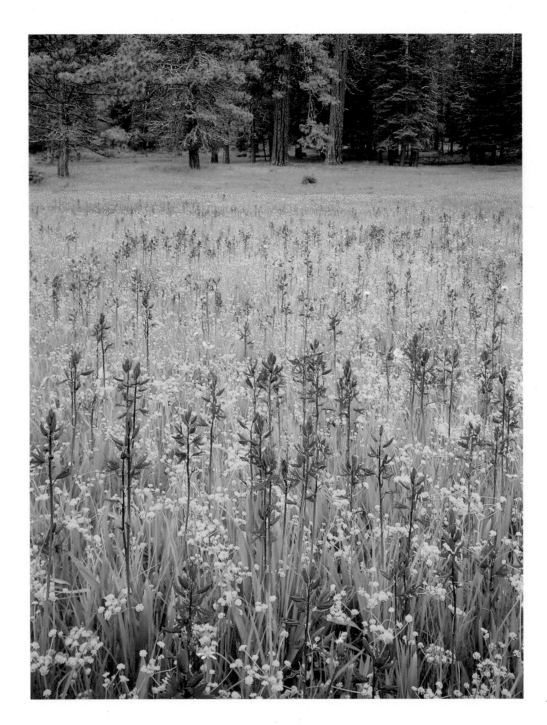

COMMON CAMAS
*Camassia quamash* ssp. *breviflora*
LEWIS' LOMATIUM
*Lomatium triternatum*

Forest Road 5
Warner Mountains
Modoc National Forest
Modoc County
June 3, 1993

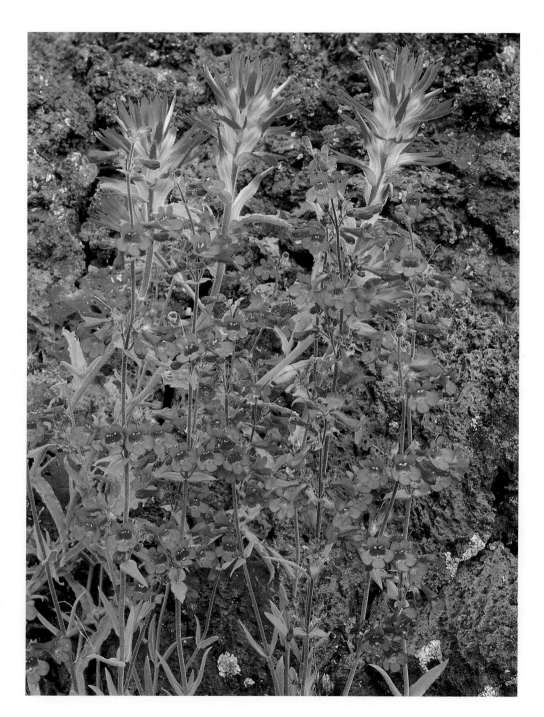

APPLEGATE'S PAINTBRUSH
*Castilleja applegatei* ssp. *pinetorum*
LOWLY PENSTEMON
*Penstemon humilis* var. *humilis*

Lava Beds National Monument
Modoc Plateau
Siskiyou County
June 3, 1993

109

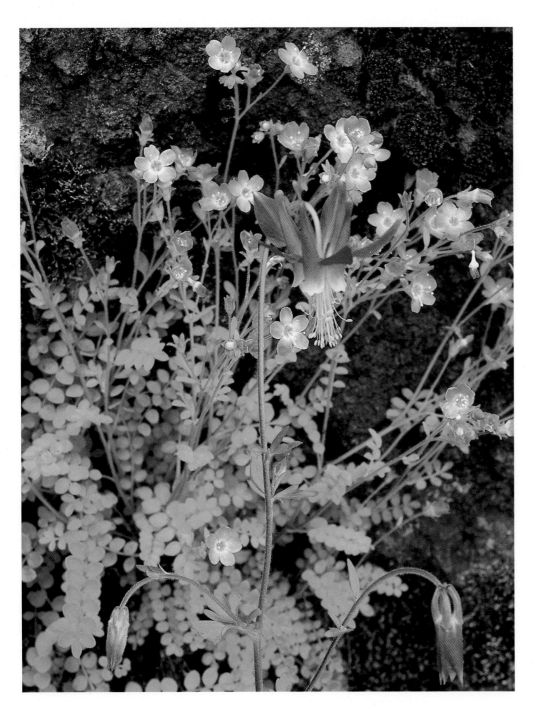

CRIMSON COLUMBINE
*Aquilegia formosa*
CALIFORNIA POLEMONIUM
*Polemonium californicum*

Frenchman Lake Road
Little Last Chance Canyon Scenic Area
Plumas National Forest
Sierra Nevada
Plumas County
June 11, 1993

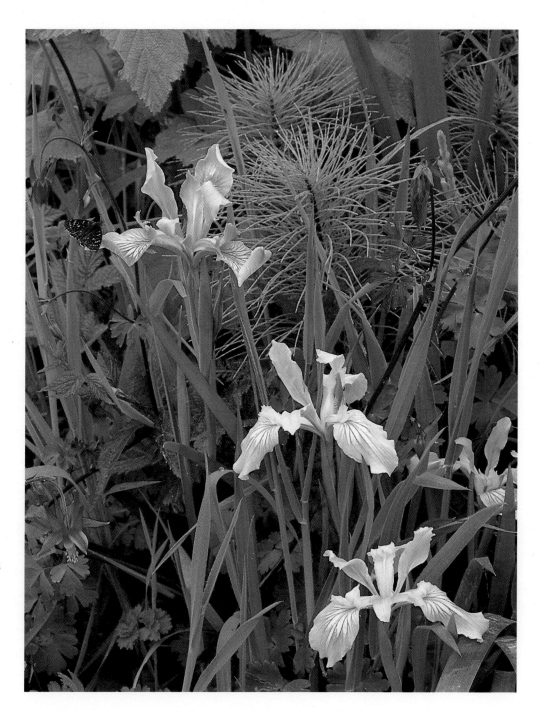

DOUGLAS' IRIS
*Iris douglasiana*
CRIMSON COLUMBINE
*Aquilegia formosa*
FIELD CRESCENTSPOT
BUTTERFLY
*Phyciodes campestris*

Coastal Trail
Redwood National Park
Del Norte County
June 7, 1984

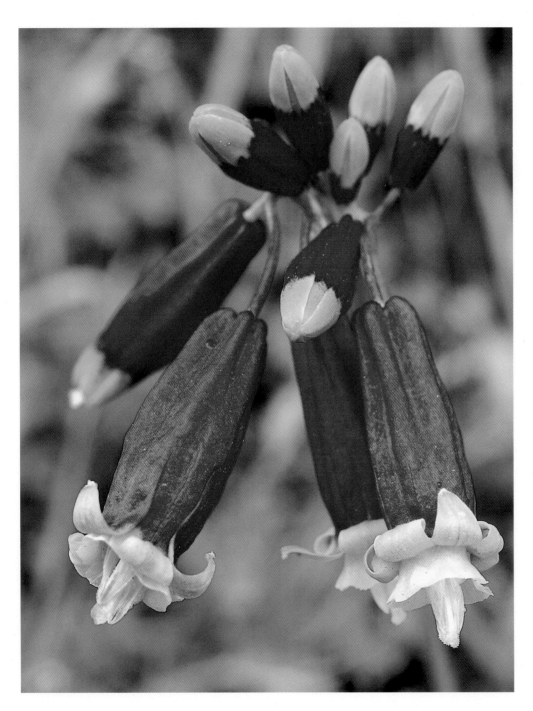

FIRECRACKER FLOWER

*Dichelostemma ida-maia*

Trinity River Canyon near Burnt Ranch
Trinity National Forest
Trinity County
June 6, 1993

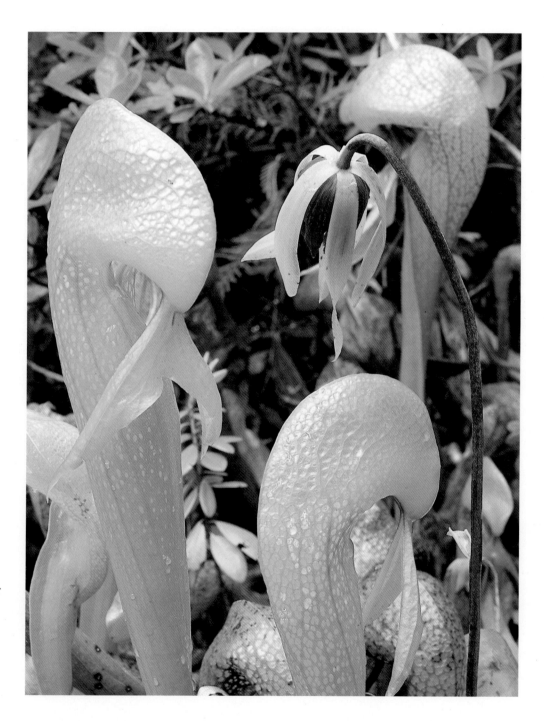

CALIFORNIA PITCHER PLANT
*Darlingtonia californica*

Stony Creek Bog
Stony Creek Trail
Siskiyou Mountains
Six Rivers National Forest
Del Norte County
June 2, 1993

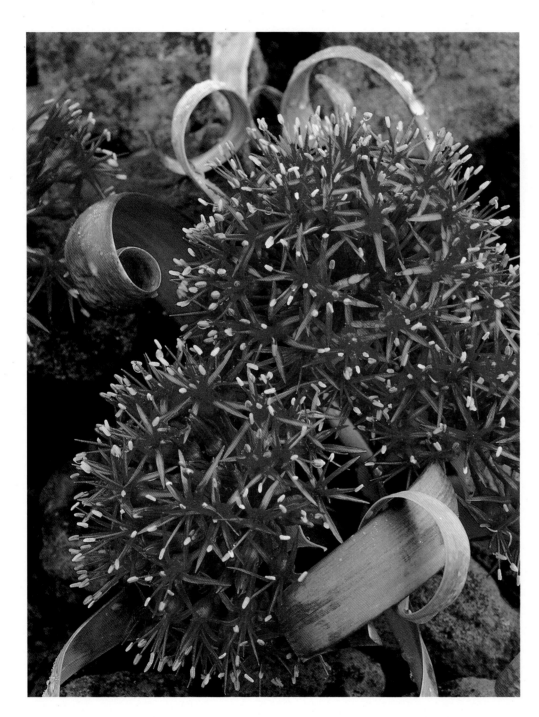

PINK STAR ONION
*Allium platycaule*

Highway 139
Modoc National Forest
Modoc Plateau
Lassen County
June 5, 1993

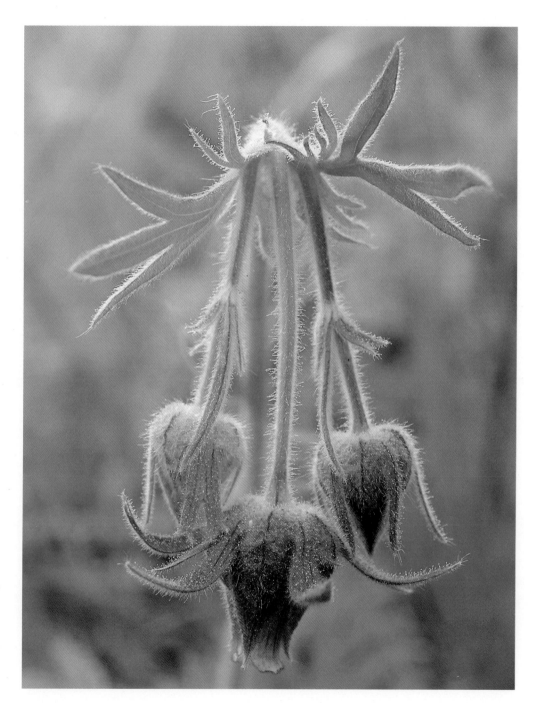

OLD MAN'S WHISKERS
*Geum triflorum*

Highway 139
Near Henski Reservoir
Modoc National Forest
Modoc Plateau
Modoc County
June 3, 1993

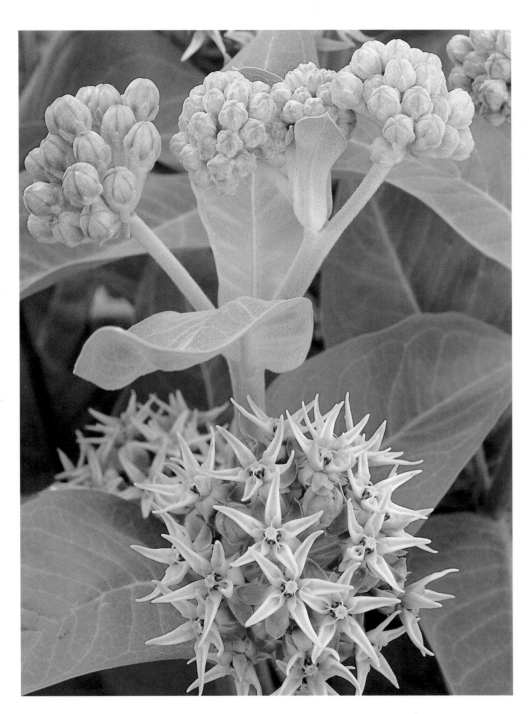

SHOWY MILKWEED
*Asclepias speciosa*

Highway 395
West Fork Walker River Canyon
Toiyabe National Forest
Sierra Nevada
Mono County
June 10, 1993

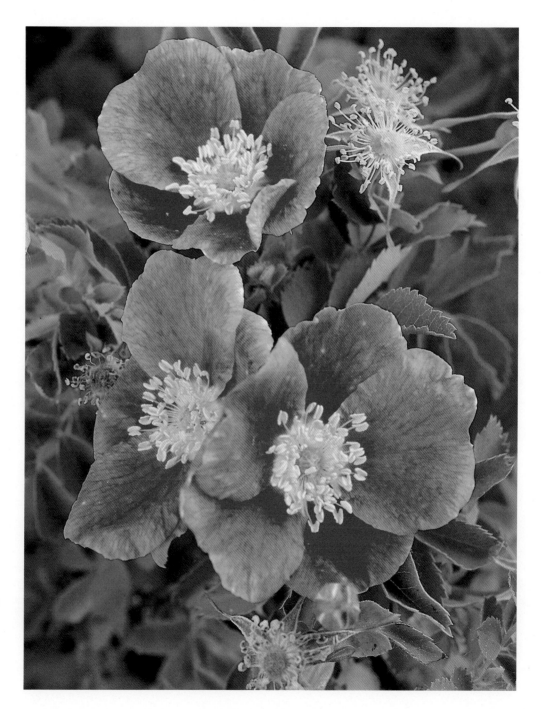

INTERIOR ROSE
*Rosa woodsii* var. *ultramontana*

Highway 395
West Walker River Canyon
Toiyabe National Forest
Sierra Nevada
Mono County
June 10, 1993

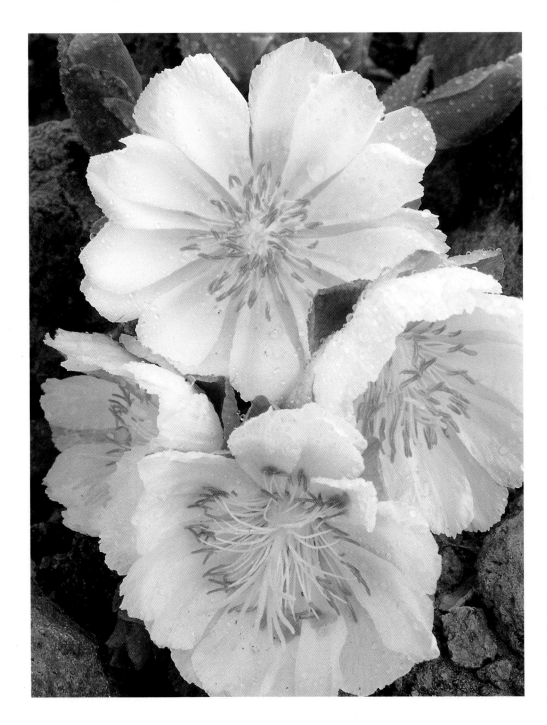

BITTER ROOT
*Lewisia rediviva*

Forest Road 31
Warner Mountains
Modoc National Forest
Modoc County
June 30, 1993

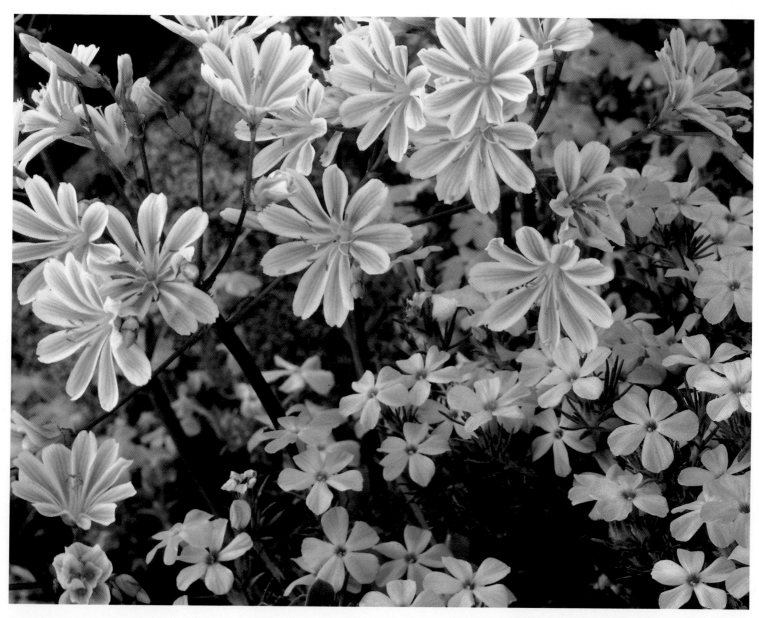

CLIFF MAIDS  *Lewisia cotyledon* var. *cotyledon*
SPREADING PHLOX  *Phlox diffusa*

Devil's Punchbowl ~ Siskiyou Mountains ~ Siskiyou Wilderness
Klamath National Forest ~ Siskiyou County
June 17, 1984

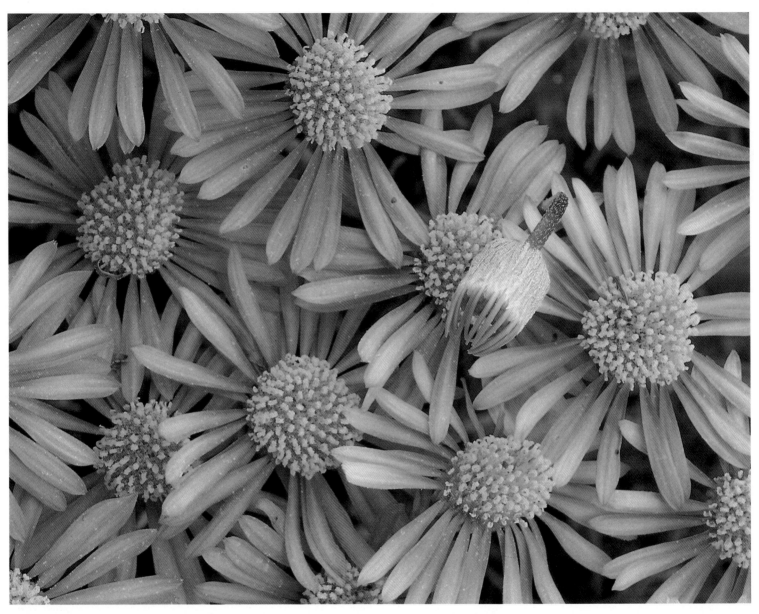

THREAD-LEAF FLEABANE DAISY
*Erigeron filifolius* var. *filifolius*

Highway 139 ~ Modoc National Forest
Modoc Plateau ~ Modoc County
June 29, 1993

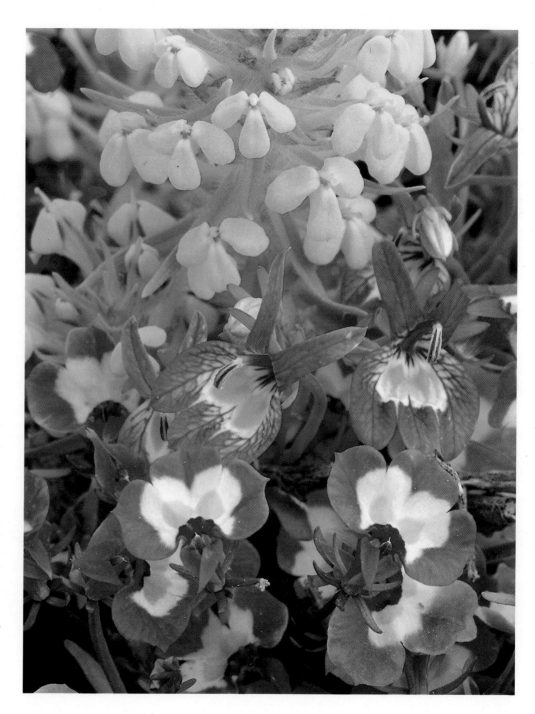

FIELD OWL'S-CLOVER
*Castilleja campestris* ssp. *campestris*
TWO-HORNED DOWNINGIA
*Downingia bicornuta*
BACH'S DOWNINGIA
*Downingia bacigalupii*

Vernal pools near Beeler Reservoir
Highway 139
Modoc National Forest
Modoc Plateau
Modoc County
June 30, 1993

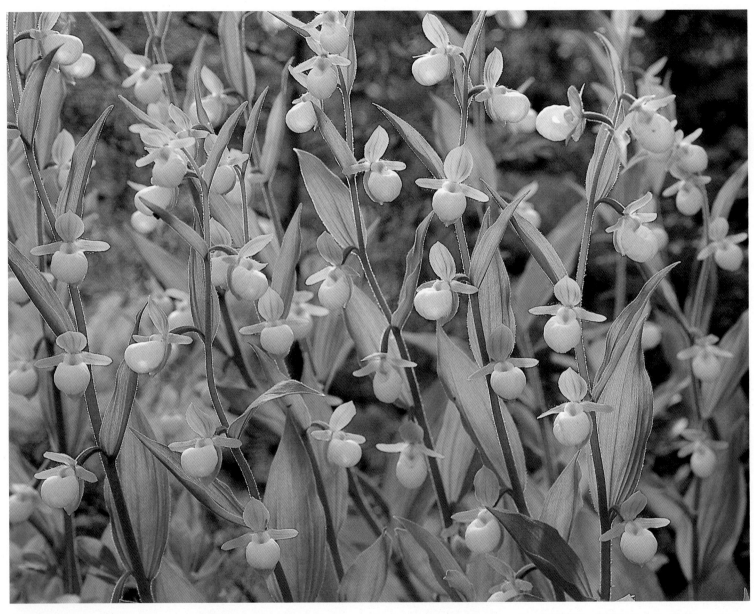

CALIFORNIA LADY'S-SLIPPER

*Cypripedium californica*

Forest Road 18NO7 ~ Middle Fork Smith River Canyon
Siskiyou Mountains ~ Six Rivers National Forest ~ Del Norte County
July 2, 1993

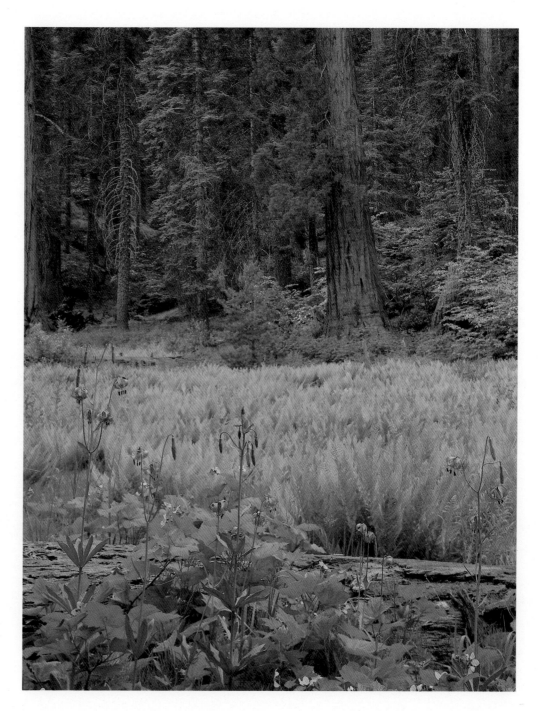

LEOPARD LILY
*Lilium pardalinum*
GIANT SEQUOIA
*Sequoiadendron giganteum*

Hazelwood Nature Trail
Giant Forest
Sequoia National Park
Sierra Nevada
Tulare County
June 27, 1985

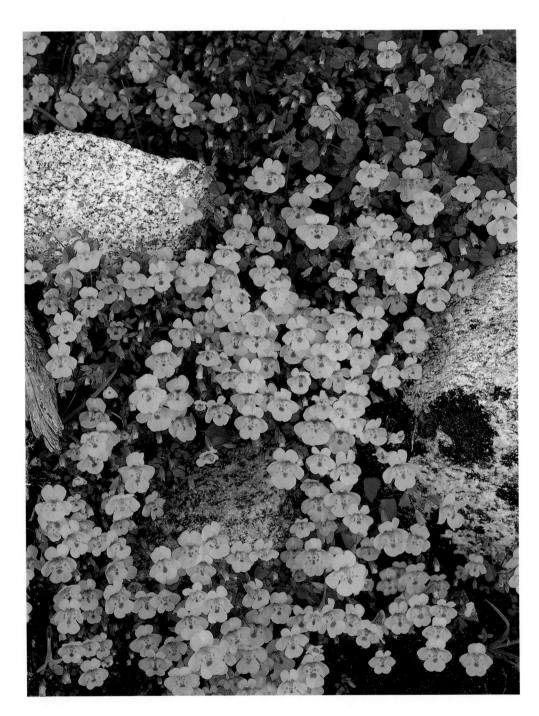

COMMON YELLOW
MONKEYFLOWER
*Mimulus guttatus*

Caribou Lakes Trail
Trinity Alps Wilderness
Salmon Mountains
Klamath National Forest
Siskiyou County
June 24, 1990

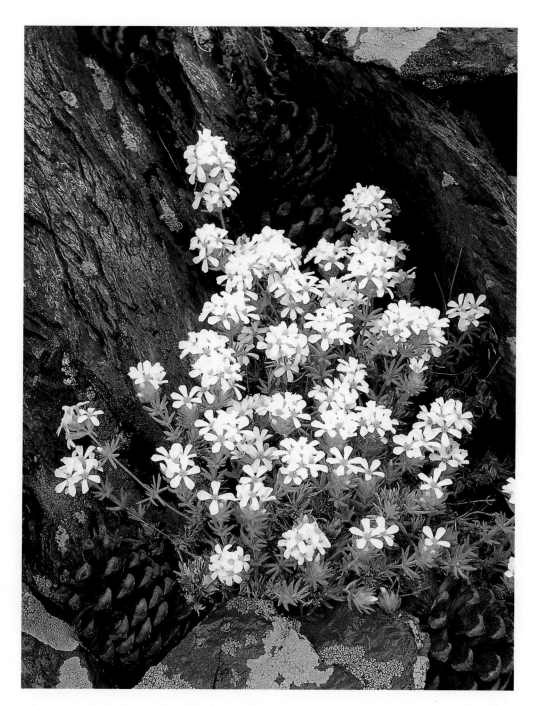

NUTTALL'S LINANTHUS
*Linanthus nuttallii* ssp. *pubescens*
BRISTLECONE PINE CONES
*Pinus aristata*

Ancient Bristlecone Pine Forest
White Mountains
Inyo National Forest
Inyo County
July 15, 1993

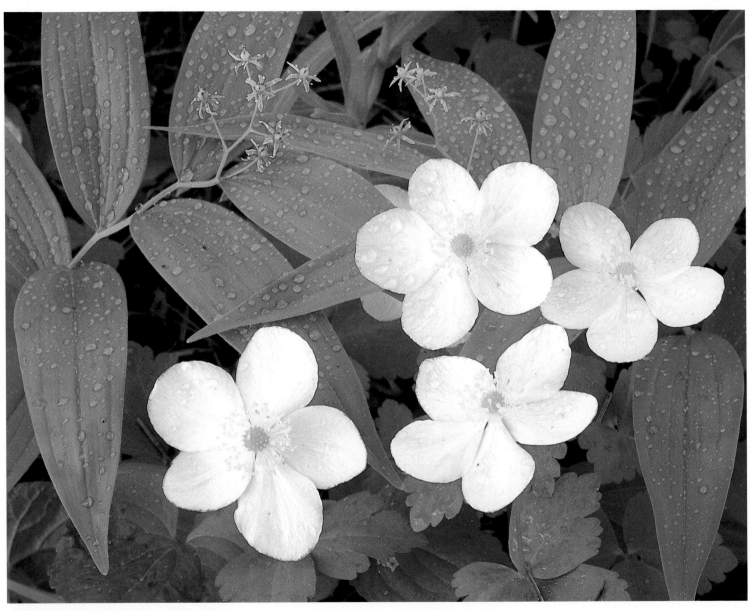

COLUMBIA WINDFLOWER  *Anemone deltoidea*
SLIM SOLOMON'S SEAL  *Smilacina stellata*

Doe Flat Trail ~ Siskiyou Wilderness ~ Siskiyou Mountains
Klamath National Forest ~ Siskiyou County
July 20, 1993

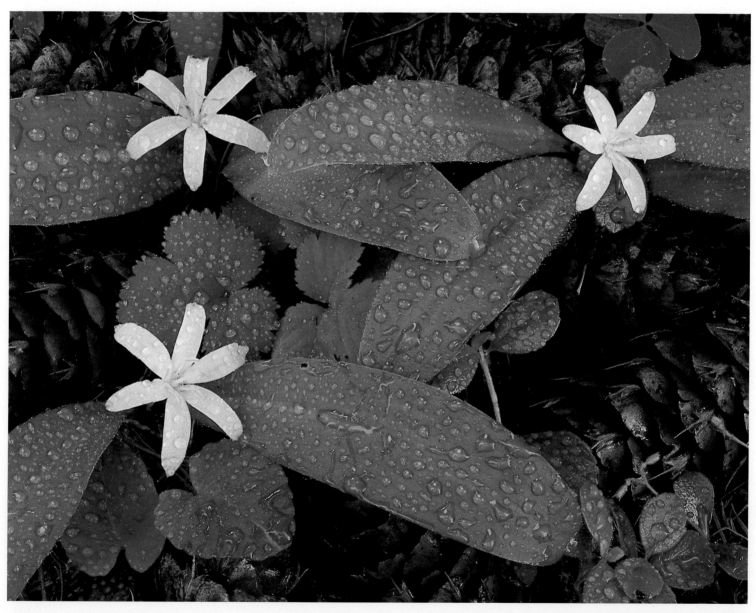

QUEEN CUPS  *Clintonia uniflora*
DOUGLAS–FIR CONES  *Pseudotsuga menziesii*

Buck Lake Trail ~ Siskiyou Wilderness ~ Siskiyou Mountains
Klamath National Forest ~ Siskiyou County
July 21, 1993

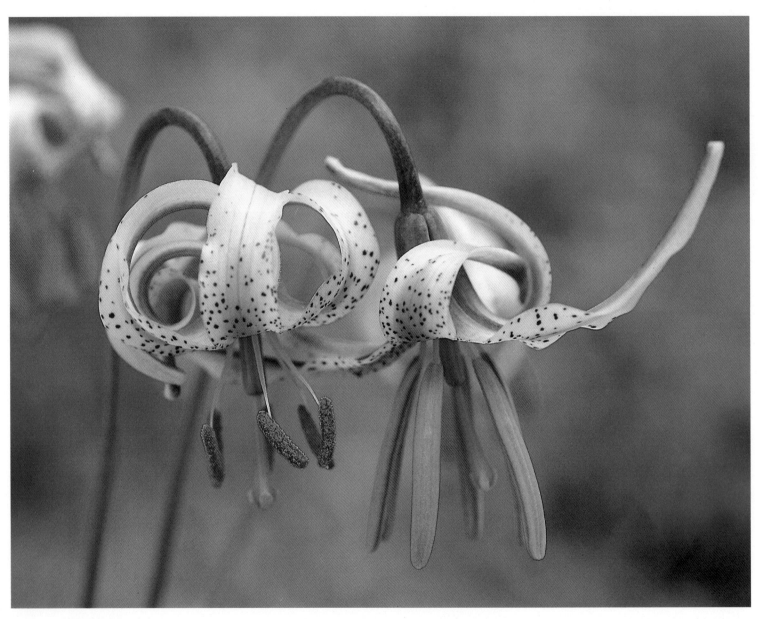

KELLOGG'S TIGER LILY
*Lilium kelloggii hybridized with columbianum*

<div align="right">

Forest Road 16 ~ Siskiyou Mountains
Six Rivers National Forest ~ Del Norte County
July 21, 1993

</div>

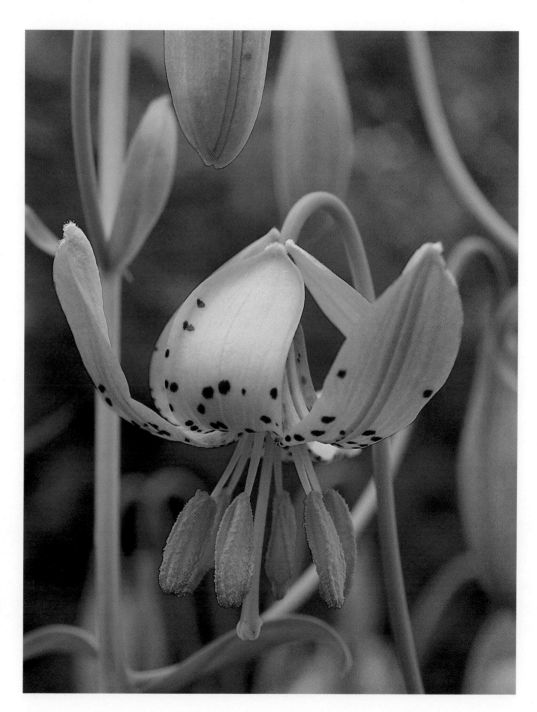

WIGGIN'S LILY
*Lilium pardalinum* ssp. *wigginsii*

Buck Lake Trail
Siskiyou Wilderness
Siskiyou Mountains
Klamath National Forest
Siskiyou County
July 20, 1993

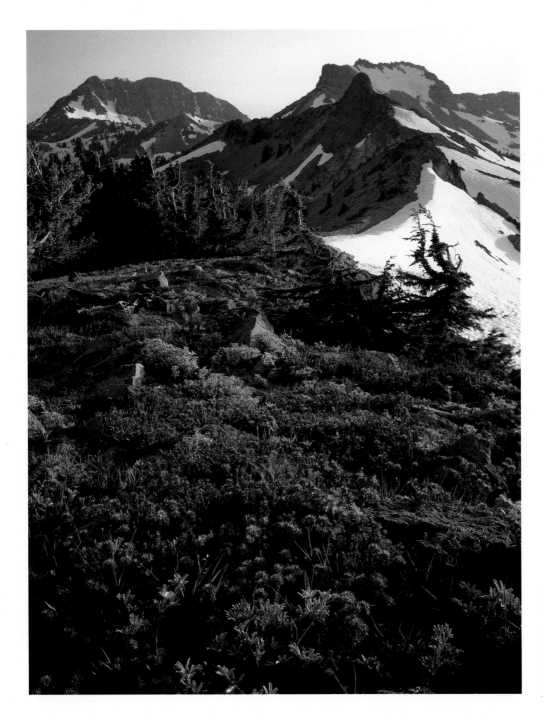

MOUNTAIN HEATHER
*Phyllodoce breweri*

Ski Heil Peak
Mount Diller & Brokeoff Mountain
Lassen Volcanic National Park
Cascade Range
Shasta County
July 11, 1985

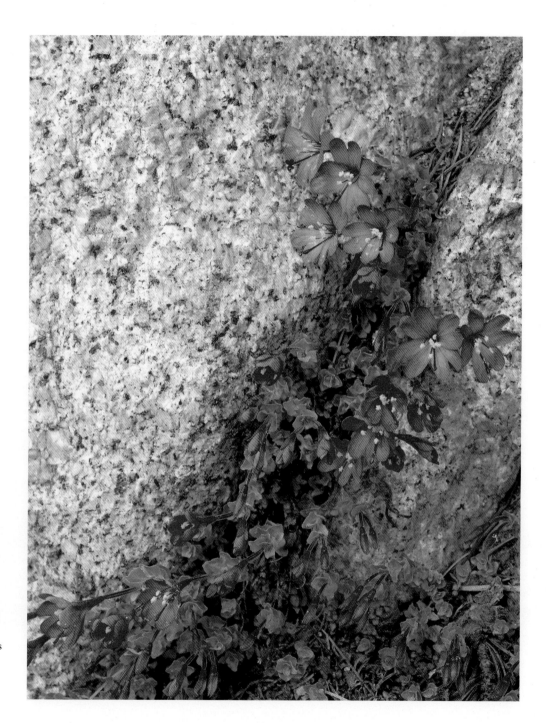

ROCK FRINGE
*Epilobium obcordatum*

Mono Pass Trail
John Muir Wilderness
Inyo National Forest
Sierra Nevada
Inyo County
July 21, 1984

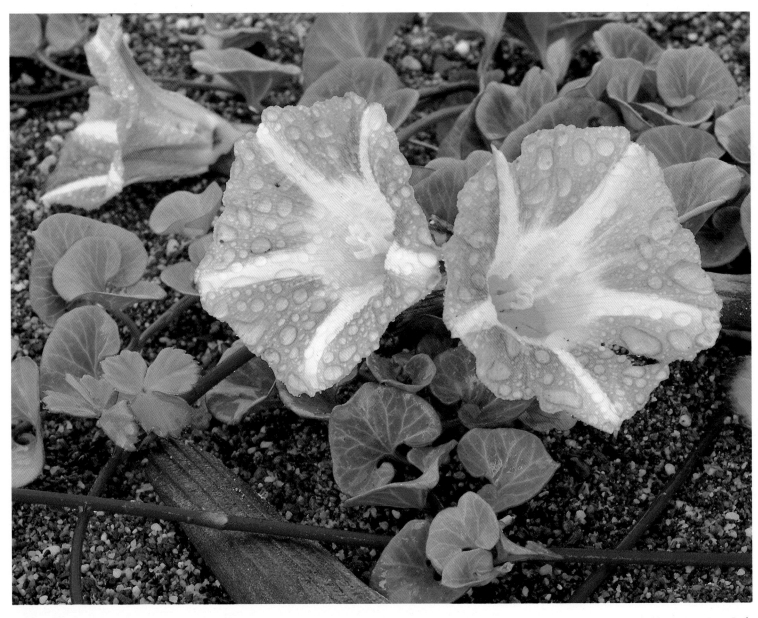

BEACH MORNING GLORY
*Calystegia soldanella*

Dry Lagoon ~ Humboldt Lagoons State Park
Humboldt County
July 20, 1993

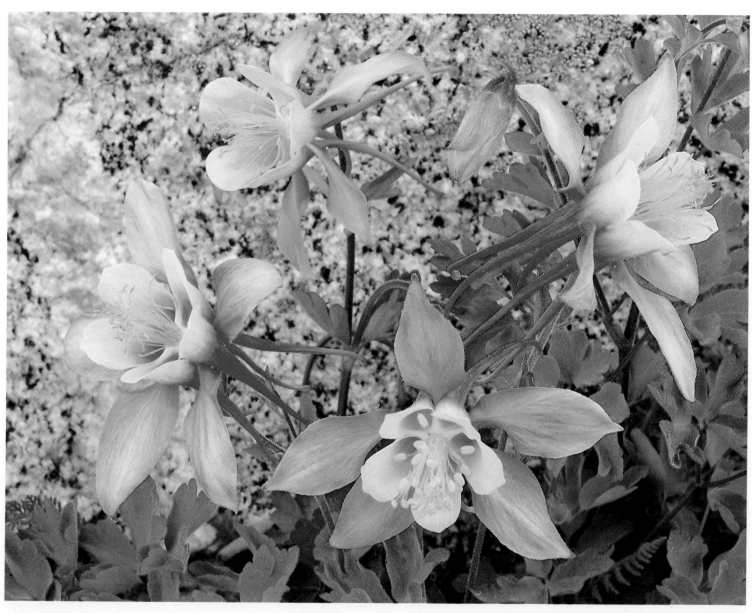

COLVILLE'S COLUMBINE
*Aquilegia pubescens*

Little Lakes Valley near Long Lake ~ John Muir Wilderness
Inyo National Forest ~ Sierra Nevada ~ Inyo County
July 14, 1993

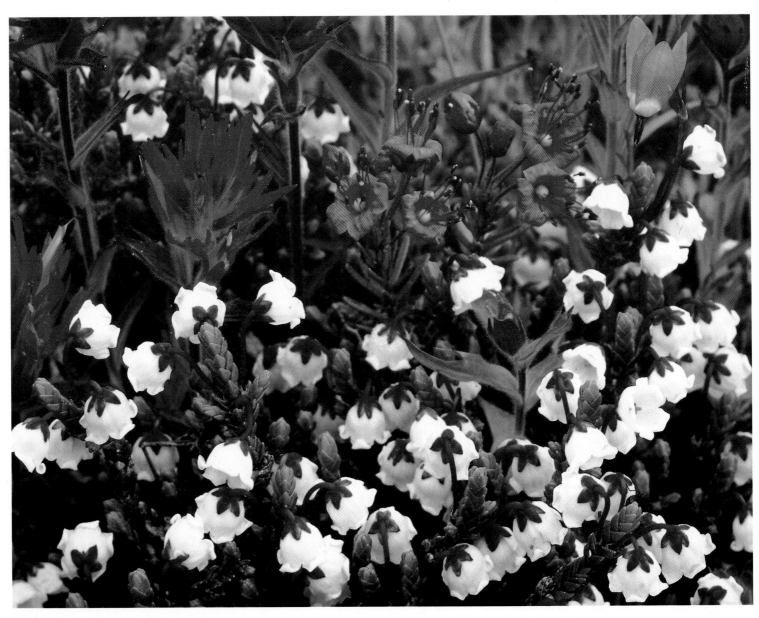

WHITE HEATHER *Cassiope mertensiana*
MOUNTAIN HEATHER *Phyllodoce breweri*
SMALL-FLOWERED PAINTBRUSH *Castilleja parviflora*
JEFFREY'S SHOOTING STAR *Dodecatheon jeffreyi*

John Muir Trail ~ Garnet Lake Basin
Ansel Adams Wilderness ~ Inyo National Forest
Sierrra Nevada ~ Madera County
July 11, 1985

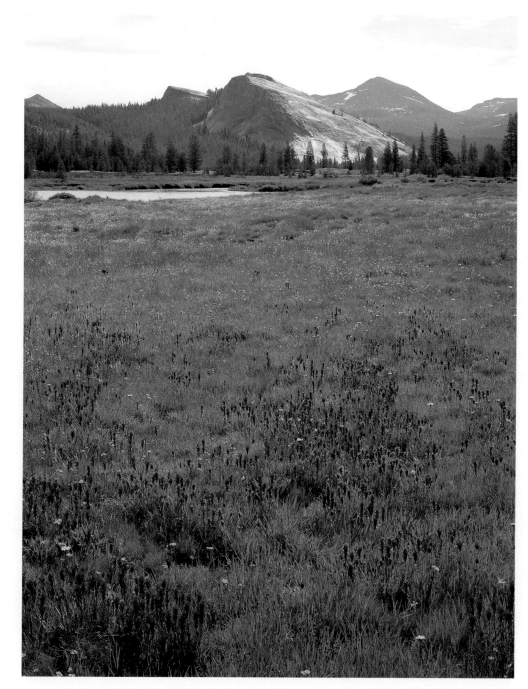

LEMMON'S PAINTBRUSH
*Castilleja lemmonii*
CLUB–MOSS IVESIA
*Ivesia lycopodioides* ssp. *megalopetala*
WESTERN BISTORT
*Polygonum bistortoides*
MEADOW ASTER
*Aster alpigenus* var. *andersonii*

Tuolumne Meadows
Lembert Dome
Yosemite National Park
Sierra Nevada
Tuolumne County
July 19, 1984

ELEPHANT'S HEAD
*Pedicularis groenlandica*
WHITE-FLOWERED
BOG-ORCHID
*Platanthera leucostachys*

Headwaters of the
North Fork Yuba River
Yuba Pass
Sierra County
July 15, 1993

## PHOTOGRAPHER'S NOTES

I used an assortment of photographic equipment in making these photographs. My primary tools since 1975 have been several generations of Arca-Swiss view cameras which I shoot in both 4x5 and 2¼x2¾ formats. The 4x5 works best for the grand landscapes, the 2¼x2¾ for close-ups. Most 35mm work was done with a Nikkor 60mm f2.8 micro lens on a Nikon 8008. I often used a polarizing screen for the view camera shots to reduce glare and contrast. For much of the close-up work I employed the use of flexible loops stretched with white fabric, called Flex Fills, both to shield my subject from the wind and to create soft light by shading. I also modified a Bogen tripod to lay flat on the ground. The older images were shot using Kodak Ektachrome 64 daylight film; after 1990 I used Fuji Velvia film.